Alexander

CALDER

/

David

SMITH

Hauser & Wirth Publishers

CONTENTS

FOREWORD

Sometime last year, I mentioned to Alexander S. C. "Sandy" Rower, grandson of Alexander Calder and President of the Calder Foundation, that I could not find any record of a joint exhibition that thoroughly explored and celebrated the achievements of both Alexander Calder (1898–1976) and David Smith (1906–1965). To my astonishment, he confirmed not only that such a show had never happened, but that he and Peter Stevens, Executive Director of The Estate of David Smith, had just recently conversed about collaborating on one.

The love and passion that Manuela and I share for sculpture in general—and for both of these artists in particular—has deep roots. Over the past twenty-five years, our gallery has been a major force behind the appreciation of sculpture, and it strikes us as perhaps telling that Calder and Julio González, Smith's artistic progenitor, were both included among our very first exhibitions in Zürich in 1992!

The dialogue between Calder and Smith, two titans of twentieth-century sculpture, has echoed through the halls of Hauser & Wirth in Zürich, and well beyond, over the past three years. *Calder in the Alps*, held at our Alpine outpost in Gstaad in July 2016, was a great success. In June 2016, our debut exhibition on Smith highlighted his late works and his bridging of two- and three-dimensional media. And back in 2015, Calder's pioneering kinetic sculpture unfolded new dimensions alongside the art of Francis Picabia.

So it is with great pride and excitement that both artists' estates are collaborating for the very first time on this important exhibition in Zürich. Drawn from the period between the early 1930s and the mid-1970s, the selection of works conveys Calder's and Smith's tremendous innovations and how each, in his own way, transformed modern sculpture. But most importantly, it provides an experience in which the sum is far greater than its individual parts.

In addition to images of works in the exhibition, the masterful photographs of Ugo Mulas (1928–1973) are presented in this catalogue alongside the narrative astutely laid out by Elizabeth Hutton Turner and Sarah Hamill, revealing a pivotal moment for these two American artists in Spoleto, Italy, in 1962. Working with unfettered ambition to create sculptures for the celebrated Festival of Two Worlds,

both Calder and Smith exceeded expectations and, consequently, revolutionized their own sculptural practices. While nearly a decade separates them, a common link can be found between the artists at this particular moment in time, as recorded in the images of Mulas.

The works featured in our exhibition and illustrated in this catalogue contextualize the moment of parallel creative production in Spoleto. In so doing, they also demonstrate how Calder and Smith approached sculpture with an inventiveness—and with an eye toward the impact of shifting planes on perspective—that endures in its capacity to inspire.

We must acknowledge the invaluable efforts of and support provided by the Calder Foundation, The Estate of David Smith, and the Archivio Ugo Mulas. We especially wish to extend our deep gratitude to both Sandy Rower and Peter Stevens for their collaboration in bringing these two artists together and invigorating a carefully considered, fresh dialogue around Alexander Calder's and David Smith's groundbreaking innovations for sculpture, which continue to resonate today.

Iwan Wirth
President
Hauser & Wirth

INTRODUCTION

It is surprising that Alexander Calder and David Smith—two towering figures of twentieth-century sculpture—have never before been shown in dialogue. Although they first appeared together in museum surveys as early as the 1940s, and the landmark 1993 exhibition curated by Carmen Giménez, *Picasso and the Age of Iron*, provided a fresh and powerful way of seeing these two artists in context with Picasso, González, and Giacometti, a spotlight has never focused on Calder and Smith alone.

Perhaps they seem too distinct and almost oppositional with respect to each other's aesthetic. This may be because both artists have, in very different ways, been subject to stereotyped sound bites: Calder—the ingenious extrovert who commanded the Parisian avant-garde and set the simplicity of abstraction in motion; Smith—the man of iron, isolated on a mountaintop, a constructor of enigmatic, richly diverse ciphers who gave three-dimensional form to the Abstract Expressionist generation. The reality is, of course, that both of these artists passionately understood the deeper personal complexity of what they were doing. Put simply, Calder and Smith, with a distinctly American, no-nonsense "love of making," refused to accept the limitations of sculpture. They insisted that sculpture could be more intimate, more involved with the viewer's sense of time, and, especially in Calder's case, more performative in its possibilities. For both artists, it was a visual medium that had to be experienced in real time, not a tactile experience to be caressed as an object. Both understood their work to be an expression of their own sensibility, but ultimately relied, with an intensely humanist belief, on the role of the viewer to complete the experience of the work. They actively challenged the traditions of sculptural space, mass, and weight, marshaling the use of line, two-dimensional planar form, and color—in other words, the visual language of painting and drawing—to create visionary new sculpture that would influence the following generations.

For Smith, sculpting was largely a process of constructing what he referred to as "new unities" that expressed his deepest identity and forged visual connections with the myriad sources that inspired him. For Calder, it was a process of intuition,

at once direct, sinuous, and in the moment. Their resulting works, though oppositional in many ways, have a resonance in that they exist beyond the boundaries of sculpture, pressing on the limits of our perception with persistence. Smith explored the illusion of two-dimensionality in three dimensions, creating literal portals of negative space. Calder exploited the fourth dimension of time with his mobiles and the volumetric power of the void with his stabiles—heightening our experience of the present moment and our awareness of multiple, even alternate, dimensions. Both artists eschewed boundaries on multiple levels and at various intensities: presence and absence, gravity and weightlessness, the monumental and the minuscule, and materiality and immateriality, including the luminous energy inherent in the actual material.

The exhibition is far from comprehensive. Instead, it brings together very specifically chosen works by the two artists, not only shedding light on the richness of their individual practices but also offering the first opportunity to clearly see some shared interests and, surprisingly, how much these artists actually had to say to each other. Calder and Smith ultimately expressed their own unique personal, formal, poetic, and aesthetic identities. Even when they asked similar questions about line or space, weight or balance, they came up with wildly different solutions. Seeing them together in this exhibition will offer viewers a fresh understanding of what they love in these artists, and, hopefully, will make visible aspects of their work that have not been brought into focus before.

Ultimately, we hope that seeing these two artists together, even more than either one by himself, will inspire and challenge contemporary artists to find their own unlimited possibilities for sculpture.

Peter Stevens
Executive Director
The Estate of David Smith

Alexander S. C. Rower
President
Calder Foundation

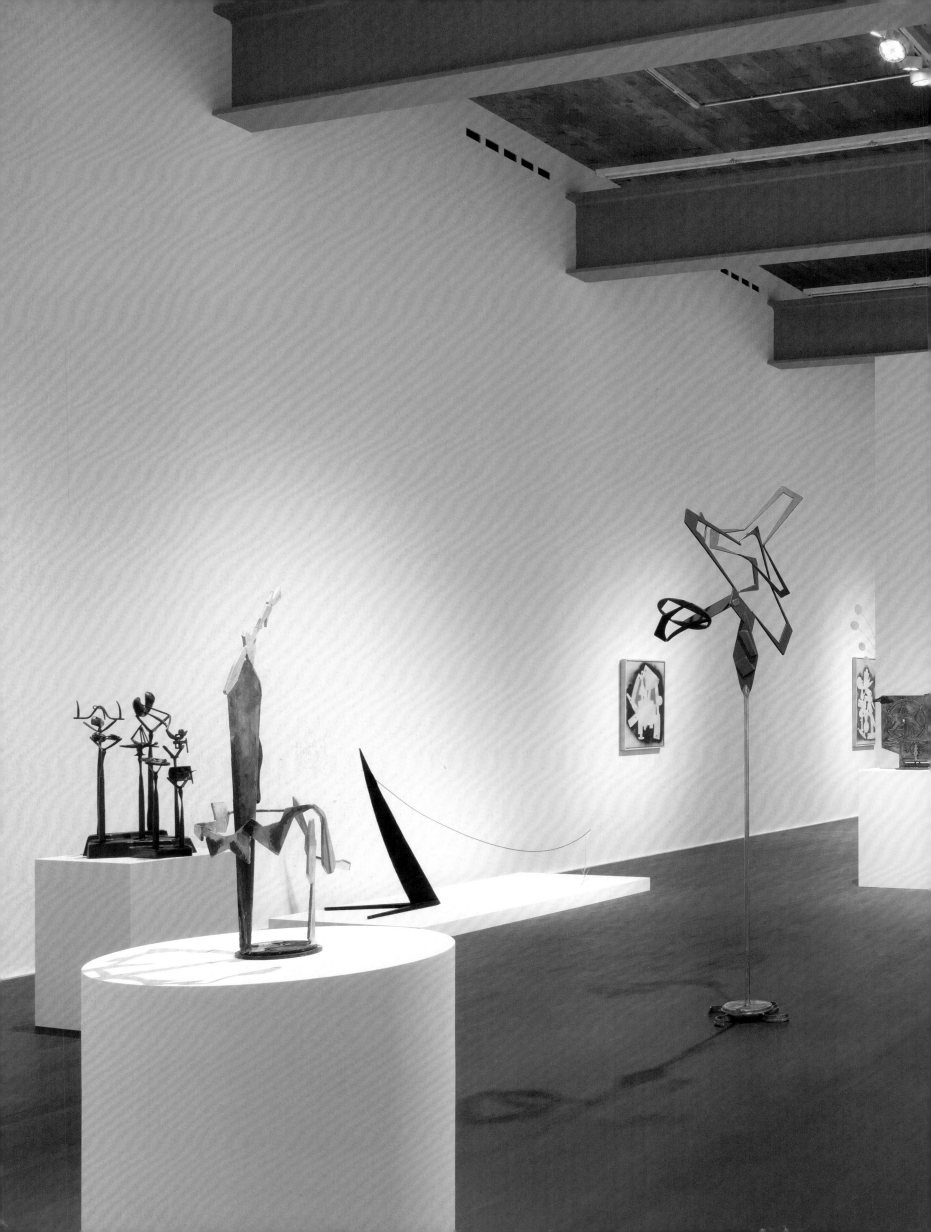

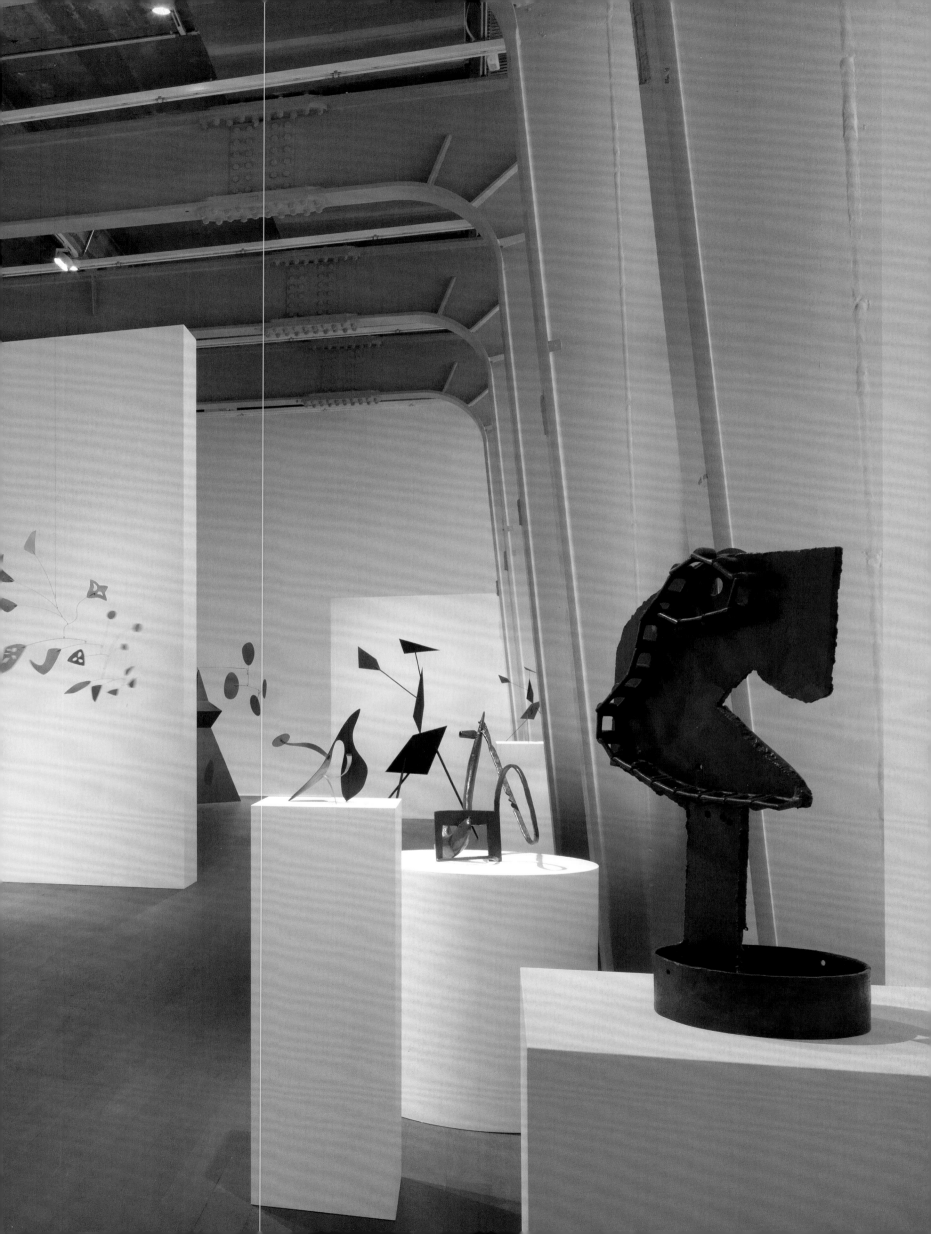

Alexander Calder, David Smith, and the Inventor's Fantasy

Elizabeth Hutton Turner

The American invents as the Greek sculpted and the Italian painted: it is genius.
　—*Times* of London, 1876[1]

A much rarer category of "radical" inventions discards these ready-made positions. The investigator constructs his own system of ready-made positions. The investigator constructs his own system of postulates and sets forth to discover the universe they alone can disclose.
　—George Kubler, *The Shape of Time*, 1961[2]

THE OCCASION AND THE CONNECTION

Alexander Calder / David Smith brings together both intimate and large-scale works created over the course of four decades by two Americans credited with radically reinventing sculpture in the twentieth century. The exhibition celebrates a time when Alexander Calder and David Smith tapped into the tensile strength of metal to make objects so shockingly new—so open and energetic and planar—that their configurations seemed to offer a whole new diagram for the pictorial realm. Not surprisingly, Calder and Smith, both of whom began their careers as painters, continued to rely upon drawing and the perceptual shift from two to three dimensions as a generative source of innovation.

Picasso and the Age of Iron, an exhibition curated by Carmen Giménez and held at the Solomon R. Guggenheim Museum in New York in 1993, set the precedent by addressing the significant connection between Calder and Smith, in succession with Picasso, González, and Giacometti. The phrase "drawing in space" connected these five artists because it best applied to their materialization of the line, to their capture of the image, and, particularly with respect to the Americans, to the force of linear trajectory into the transparent dimension beyond the page, picture plane, or frame.[3]

DIVERGENCES

Despite this connection, Calder and Smith are divergent artists. Here the contrast brings to mind what George Kubler would call different "entrances" into time.[4] What should we make of the disparate circumstances arising from the fact that eight years separate Calder, born in 1898, from Smith, born in 1906—or that the former comes of age during the Roaring Twenties and the latter during the Great Depression? Selden Rodman, who interviewed both Calder and Smith in 1956, surmised a generation gap: "Ten years earlier, Calder would have been a Beaux Arts academician—the American artist was not then ready for such freedom. Ten years later he would have been preoccupied with social significance, or fighting against it angrily—like David Smith."[5] Rodman's breathtaking generalizations aside, there is no denying the issue of timing.

Calder and Smith may have been acquaintances—after all, the New York art world in those days was a relatively small place—but they were not friends. There are no records of substantive exchanges between them: no correspondence, no conversations, no visits—with two notable exceptions. A scrap with Smith's address scrawled upon it—"David Smith / Bolton Landing, N.Y.," not in Calder's hand—exists among Calder's papers, while among Smith's papers there are two notes from Calder, the first asking whether he and a few others could stay at Bolton to do some skiing, and the second politely acknowledging Smith's apparent dismissal of the request. And one more thing: Smith actually owned a wire portrait by Calder of the painter John Graham (fig. 1; see page 55), a gift to him from Graham. But throughout his ownership, Smith never acknowledged it as an artistic influence.[6]

In 1960, when asked by interviewer David Sylvester whether his use of metal was influenced by Calder, Smith distanced himself. "No," Smith replied, "I knew metalworking before I knew Calder. And Calder is one of our great men, and he is earlier by a few years than any of the rest of us. Calder had worked in Paris quite a bit in the early days, though he did go to school here in New York at the Art Students League, I have been told."[7] Smith had been told right.

In 1926, Smith began at the Art Students League (and studied with Calder's teacher John Sloan) just as Calder finished at the school and caught the wave of Americans going to Paris. Calder continued a pattern of travel between New York and Paris for the

1　*Times* of London, 1876, quoted in Mark Calney, "The International Centennial Exhibition of 1876; or Why the British Started a World War," May 7, 2006, accessed April 11, 2017, http://larouchejapan.com/japanese/drupal-6.14/sites/default/files/text/1876-Centennial-Exhibition.pdf. Footnote 10 reads: "This *Times* statement is quoted by General Hawley in his *Report of the President to the Commission* at the final meeting of the Centennial Commission, January 15, 1879."

2　George Kubler, *The Shape of Time* (New Haven, Conn.: Yale University Press, 2008), 63.

3　Carmen Giménez, introduction to *Picasso and the Age of Iron*, exh. cat. (New York: Solomon R. Guggenheim Foundation, 1993), 16. Note: though the phrase "drawing in space" is best known, and most attributed to Julio González, in reference to Picasso's pictures in metal, in fact, "drawing in space" was first publically associated with Calder by critics at the Salon des Indépendants in 1929. Gros, in *Paris-Midi* on February 2, 1929, stated: "It looks like a drawing in space. One can imagine the patience of the sculptor armed with pincers and pliers and uncoiling around his stele the spool of copper wire that he will twist and untwist to give birth to figures." Gros quoted in Susan Braeuer Dam, "Liberating Lines," in *Calder and Picasso*, exh. cat. (New York: Almine Rech Gallery, 2016), 45.

4　Kubler, *The Shape of Time*, 5.

5　Selden Rodman, "Alexander Calder," in *Conversations with Artists* (New York: The Devin-Adair Co., 1957), 138.

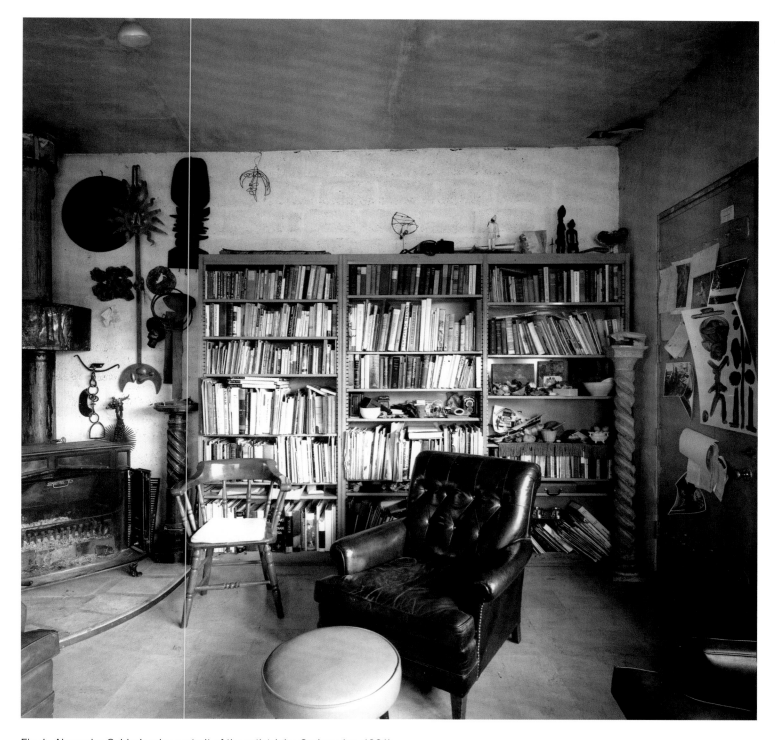

Fig. 1. Alexander Calder's wire portrait of the artist John Graham (ca. 1931)
in David Smith's living room (hanging above the bookcase, to the left),
photographed by Ugo Mulas, Bolton Landing, N.Y., 1965

6 I would like to thank Lily Lyons and Susan
 Braeuer Dam of the Calder Foundation and
 Peter Stevens of The Estate of David Smith
 for bringing these documents from the
 respective artists' archives to my attention.
 Letters from Alexander Calder to David
 Smith, dated February 19, 1941, and March 3,
 1941. The Estate of David Smith archives.

7 David Smith, interview by David Sylvester for
 BBC Radio, Rockefeller Center (New York,
 March 1960), broadcast on BBC Radio, Third
 Programme, July 29, 1960, at 8:35 pm.
 Edited version published in *Living Arts* 3

 (April 1964): 5–13. Reprinted in *David Smith
 1906–1965*, exh. cat. (Valencia: Institut
 Valencià d'Art Modern; Madrid: Museo
 Nacional Centro de Arte Reina Sofía, 1996),
 341.

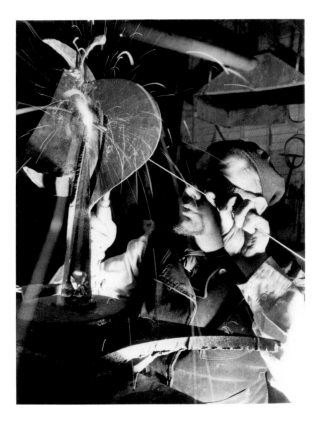

Fig. 2. David Smith welding *Head* (1938), photographed by Andreas Feininger, ca. 1938

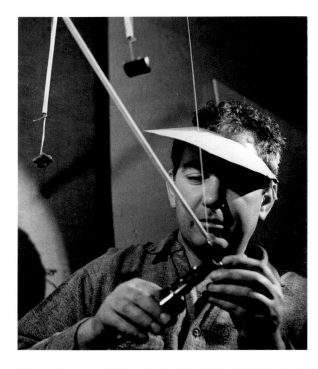

Fig. 3. Alexander Calder with *Swizzle Sticks* (1936) in his New York storefront studio, photographed by Herbert Matter, 1936

next seven years, keeping a studio in Paris until 1933, when he returned to New York with a network of contacts on both sides of the Atlantic. In the early 1930s, just as Smith was beginning his conversations with Julien Levy and Pierre Matisse, Calder had already secured shows with both of these legendary gallerists, and in the case of the latter, he had secured representation as well.

Seemingly no straight line connects Calder and Smith biographically, technically, or conceptually to the same pattern of evolution. There is a restless discontent in the expressive range of Smith's structures over decades—so much so that, as the expression goes, "a new ship had to be built for every voyage to sea."[8] Calder arrived early at the mature form of mobile and stable structures, which he then utilized as a vehicle for exploration, pursuing new experiences of space, particularly big space.

At the point of invention, each artist appears to have developed a different understanding of what he was doing. Consider the consequence of Smith's choice of the oxyacetylene torch and power saw in contrast to Calder's preference for manual tools—pliers, hammer, and file (figs. 2, 3).[9] Now consider the differing marks of the tools: the exposed weld beads of the torch in contrast to the wire loops and linkages formed by pliers, which enable the objects to negotiate gravity and encompass space. Even their approaches to simple machines, simple forms such as the lever, the level, the wedge, or the inclined plane, are distinctive. All of these contrasts demonstrate not only distinct technical but also conceptual concerns. As Rosalind Krauss has observed, Smith's thinking derived from the procedure of welding, while Calder's thinking was clarified in relation to motion[10] and, as Albert Elsen observed elsewhere, by bending wire or manipulating metal sheets.[11]

Smith's earliest welded constructions, such as *Chain Head* (1933) (see pages 53, 54), find a blunt force latent in metal that seems to match the moral weight of conscience against gravity—as if in the act of balance necessary for Smith's configurations to relate, attach, and stand upright, the artist is somehow amending a history of industry, weaponry, or other assaults against humanity. As Smith later explained, "it may be society's vulgarity, but it is my

8 Archibald MacLeish, "There Was Something about the Twenties," *Saturday Review*, December 31, 1966, 11.

9 I would like to thank Ed Ford, Professor of Architecture, University of Virginia, for his insight about the mark of artists' tools. It is worth noting that Smith also used pliers, hammers, and files in addition to power tools.

10 Rosalind E. Krauss, "Magician's Game: Decades of Transformation, 1930–1950," in *200 Years of American Sculpture*, exh. cat. (New York: Whitney Museum of American Art, 1976), 162.

11 Albert E. Elsen, *Alexander Calder: A Retrospective Exhibition*, exh. cat. (Chicago: Museum of Contemporary Art, 1974).

12 David Smith, "The New Sculpture," paper delivered for a symposium at the Museum of Modern Art, New York, February 21, 1952. Published in *David Smith 1906–1965*, 325.

13 Yvon Taillandier, "CALDER: personne ne pense à moi quand on a un cheval à faire," *XXe Siècle 1*, no. 2 (March 15, 1959). Reprinted in English in *Calder: Gravity and Grace*, exh. cat. (Bilbao: Museo Guggenheim Bilbao, 2003), 87.

14 Alexander Calder, "Que Ça bouge–à pro pos des sculptures mobiles" (manuscript, 1932). Calder Foundation archives. Translation courtesy Calder Foundation, New York.

15 Pierre Matisse quoted in "Events in a Life," in *David Smith by David Smith: Sculpture and Writings*, ed. Cleve Gray (London: Thames & Hudson, 1968), 27.

16 See Arnauld Pierre, "Thoughts on Transparency," in *Transparence: Calder / Picabia*, exh. cat. (Zürich: Hauser & Wirth, 2015), 10. I would like to thank Susan Braeuer Dam for

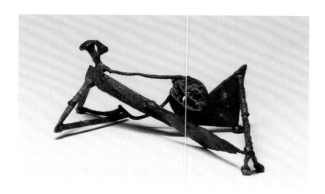

Fig. 4. An example of one of David Smith's *Reclining Figure* sculptures, this one from 1933, photographed by David Heald

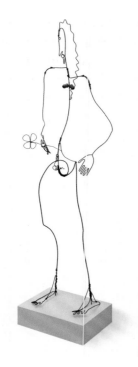

Fig. 5. Alexander Calder, *Spring* (1928), photographed by David Heald

beauty."[12] Calder's early wire objects, such as the aforementioned portrait of John Graham (fig. 1; see page 55), on the other hand, find a source for elation in the efficiencies of wire emptying out the weight of sculptural history, what he called "mud piled up on the floor."[13] Calder's suspended and open structure seeks ways for the wire lines to be put in relation in space—big space—in the hopes of, as he said, "a new possibility of beauty."[14]

Not surprisingly, each artist provoked a decidedly different response from his audience. Smith specifically recalled the time dealer Pierre Matisse found one of his reclining bronze figures (fig. 4) particularly hard on the eyes: "It looked better before you unwrapped it."[15] Conversely, Calder contended with the issue of invisibility. At the 1929 Salon des Indépendants, a French critic noted one visitor literally walking through Calder's wire objects unaware (fig. 5).[16] By the 1940s, the generational divide between Calder and Smith was solidified by the coincidence of the influential critic Clement Greenberg's dismissive review of Calder's highly popular retrospective at MoMA and his recognition of Smith as a promising young sculptor to watch.[17]

AND YET, THEY MEET?[18]

Yet one key documented historic event did tie Calder and Smith to a shared—and instructive—experience. Exhibiting in Spoleto, Italy, in 1962 is now a legendary moment in the careers of both artists, although one rarely told as a shared story. Though the ancient hill town nestled at the edge of the Apennines was hardly a metropolis, it nevertheless was chosen to host the project called *Sculptures in the City*, a compelling prospect for modern art on the occasion of Gian Carlo Menotti's Festival of Two Worlds. The sculpture exposition, the first of its kind in the history of a festival devoted to performances of music and modern drama, ultimately comprised 106 works by 52 sculptors. Calder and Smith were among ten sculptors commissioned—a group that also included Eugenio Carmi, Lynn Chadwick, Ettore Colla, Pietro Consagra, Nino Franchina, Carlo Lorenzetti, Beverly Pepper, and Arnaldo Pomodoro, all invited by curatorial impresario Giovanni Carandente—to make new things for the occasion.[19] Here we find Calder and Smith equally joined, each at the top of his game in the creation of new work.

Along with the steelmaker Italsider, who sponsored the Spoleto display and provided its participants with machinery and materials, in addition to the assistance of professional welders and shipbuilders, Carandente turned to Calder and Smith with unique yet equally enticing propositions, each

providing me with the full citation and quote. "A sculptor exhibits a wire statue depicting a naked woman. It is difficult to see and a visitor of average size passed through this beauty without even noticing it. A good statue should be able to be seen from anywhere. Today one can see a good statue anywhere." Maurice Raynal, *Intransigeant*, January 21, 1929.

17 "Calder's art is always called gay and exuberant, and it is. But more seems to be wanted. This particular world lacks history. Lots of things go on in it but nothing happens. . . . Good taste has its advantages, and Calder is one of our best artists. I do not think that he is in the same class as David Smith, who works in a similar medium and derives from the same ancestry, but he comes next." Clement Greenberg, "Alexander Calder: Sculpture, Constructions, Jewelry, Toys, and Drawings," *Nation*, October 23, 1943. Reprinted in John O'Brian, ed., *Clement Greenberg: The Collected Essays and Criticism* (Chicago: University of Chicago Press, 1988–95), 1:159.

18 An allusion to Fernand Léger, preface to *Alexandre Calder: Volumes–Vecteurs–Densités / Dessins–Portraits*, exh. cat. (Paris: Galerie Percier, 1931). I would like to thank Susan Braeuer Dam for suggesting the appropriateness of Léger's words here.

19 William McHale, "A Town Full of Sculpture," *Time*, August 24, 1962, 48, 50. The Estate of David Smith, clipping archives.

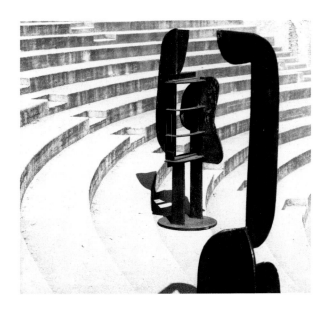

Fig. 6. David Smith, *Voltri XVIII* and *Voltri V* (both 1962), installed at the Roman amphitheater, photographed by Ugo Mulas, Spoleto, 1962

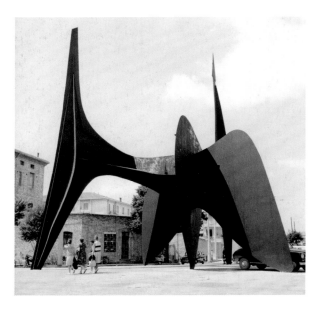

Fig. 7. Alexander Calder, *Teodelapio* (1962), photographed by Alberto Zanmatti, Spoleto

centering on a free rein to invent. Carandente initially asked Calder to make a model of a large "object" to serve as a symbolic entrance to the city,[20] while Menotti invited Smith to work in an Italsider factory for thirty days to fabricate two new works. (Smith did not remember being given a specific number but did recall that Menotti promised to name an opera in honor of his daughters.)[21]

At the very least, Carandente knew that something unprecedented was about to happen and enlisted the photographer Ugo Mulas to capture it on film. What "it" might look like was another matter. As he said, "The solution was not, of course, part of any prearranged plan."[22] Carandente, described as a "sorcerer's apprentice," was happy to wait to see whatever the setting inspired.[23]

These contingencies yielded surprises. Smith arrived in May and promptly created his two works within days; by the end of the prescribed month, he had made a total of twenty-seven works—nothing less than "a gusher of art," in the words of a reporter from *Time*.[24] Carandente wondered where to put them. Emergency measures were taken to find exhibition space in an unused amphitheater (fig. 6). For his part, Calder, in correspondence with Carandente, worked remotely, sending a maquette in May but not arriving in Spoleto himself until August 1, in response to a distressed call from those on site at the train station who were contending with the stability of his giant object.[25] The construction on what was at the time believed to be the world's largest modern metal sculpture lasted for the remainder of the festival, which ended August 31.[26] The differences in timing and process that produced Smith's multitudes and Calder's colossus, *Teodelapio* (fig. 7), belie a similar imaginative investment in Spoleto, which is the most revealing aspect of their stories. Their two fantasies are equally matched.

SMITH'S ENTRANCE

Smith's fantasy begins with his choice to use the recently decommissioned Italsider factory (fig. 8) in the town of Voltri (near Genoa) instead of its new replacement in Cornegliano. In Voltri, Smith had full access to the mill complex and the use of any materials available, even carts and wagons. The detritus of the newly abandoned space suggested to him the cyclic stream of industrial invention, production, distribution, consumption, and obsolescence. As Smith's "Report on Voltri" described, the complex of factories formerly found in Voltri once made "springs, trucks, parts for flatcars, bolts, spikes, balls, many things by forging," but,

20 "He wrote me in Roxbury, asking for my collaboration. One object lent itself to that large scale. Because it was to arch the crossroads at the entrance, I made the model higher in the crotch—thirty inches long, thirty inches high. Italsider, a shipbuilder in Genoa, built the thing." Alexander Calder quoted in Robert Osborn, "Calder's International Monuments," *Art in America*, March–April 1969, 38.

21 "Menotti offered [to] dedicate opera [to] daughters Candida, Rebecca (7 + 8 years) I said fine they like your works, I'll go . . ." Letter, David Smith to David Sylvester, November 12, 1962. Reprinted in Giovanni Carandente, *Voltron* (Philadelphia: Institute of Contemporary Art, 1964), 11.

22 Carandente, *Voltron*, 8.

23 McHale, "A Town Full of Sculpture," 48.

24 Ibid., 53.

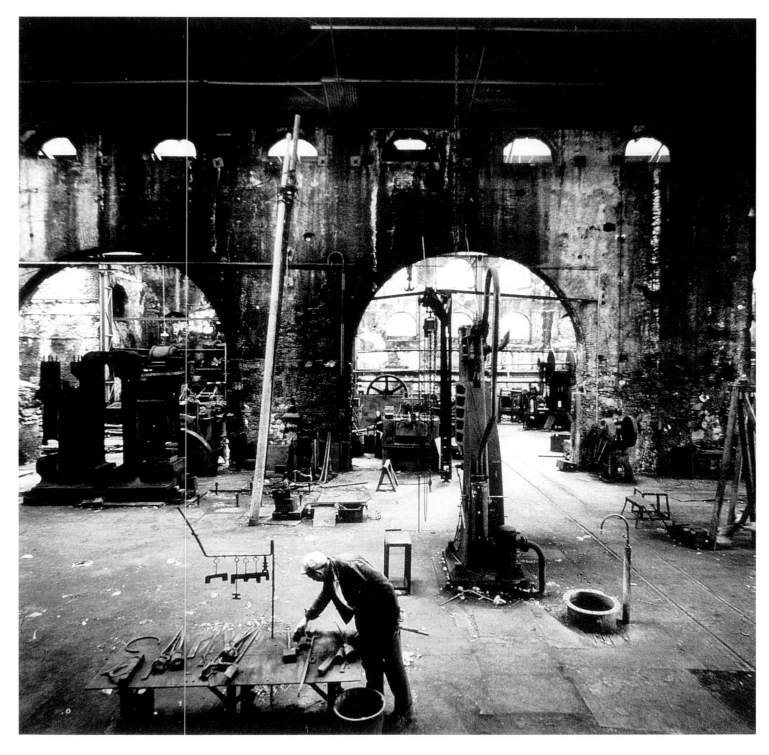

Fig. 8. David Smith in the Italsider factory,
photographed by Ugo Mulas, Voltri, 1962

25 This event was recounted by Calder in
 Osborn, "Calder's International Monuments,"
 38. The documentation of the Spoleto
 commission includes a letter from Alexander
 Calder to Giovanni Carandente, March 27,
 1962; a letter from Alexander Calder
 to Giovanni Carandente, April 20, 1962; a
 telegram from Alexander Calder to James
 Johnson Sweeney, July 24, 1962; and
 a memorandum in a letter from Alexander
 Calder to Giovanni Carandente, August 6,
 1962. All are published in Giovanni
 Carandente, *Calder*, exh. cat. (Milan: Electa,

 1983). Also see Giovanni Carandente,
 Teodelapio: Alexander Calder (Milan: Charta,
 1996), 17–69, which includes corre-
 spondence, drawings, and photographs of
 Teodelapio under construction.

26 McHale, "A Town Full of Sculpture," 53.

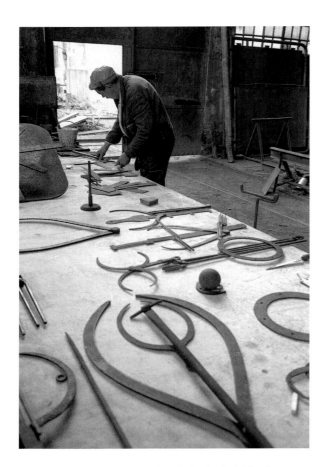

Fig. 9. David Smith at a worktable in the Italsider factory, photographed by Ugo Mulas, Voltri, 1962

by the time of the artist's arrival, had been "consumed by automation."[27]

Smith immediately entered the stilled factory buildings and reset the clock. He worked twelve-hour days, dragging parts between buildings. He gathered the remnants, the plates, pieces, and trimmings, and began to identify objects, handmade tools, things left at the forge partially made, and invested them with a new purpose. Through the rhythms of this activity, Smith internalized the clock and the urgency of keeping ahead of the salvage crews, with their gondolas and switch engine, coming to feed the melt.

By whitewashing the workbenches from across the factory, and laying out objects on them, he was literally setting the stage (fig. 9).[28] He would be the worker and, through the license of his imagination, he would also be the historian and the collector of a trove of things as great as any assembled for the museums or castles of Genoa. Smith stated at the time that "there are no sedan chairs in an old factory,"[29] believing all the while that out of the work stream of his assemblies would come something equally marvelous. Such was this inventor's fantasy.

Given a process wedded to time and circumstance—literally, factory time—the specific duration of thirty days at Voltri suggested to Smith a new kind of sculpture. Whereas at Bolton Landing the artist might have waited for the delivery of new metal sheets, in Voltri extant materials—similar to the farm equipment in his Agricolas—began to dominate in new ways. Finished works were identified, sequenced, and numbered with roman numerals in the order of completion. The first assembly coalesced (desperately, according to Smith) as stacking plates (fig. 10). Next came a newly discovered shape, which Smith dubbed "chopped cloud," as in the chopped-off end piece when a billet rolls out. This he attached as a pennant streaming through a circle standing on pincers. When *Voltri II* (fig. 11) was completed on May 26 and shipped on June 6, Smith's obligation to Carandente had in fact been met, but the artist had four other works in process comprising growing variations of chopped clouds standing opposed and reversed, or facing ends on metal tables. Ultimately, these variations are manifested in no less than eight Voltris, numbered II, IV, V, IX, XI, XIV, XV, and XVII.[30]

Out of these initial configurations, *Voltri VI* (fig. 12) was perhaps the most radical due to its large operative wheels. Here were simple machines—agents of mobility whose shapes were as alive in Smith's mind as the shape of the circle and the sun. Smith made three such assemblies, whose large forgings necessitated transport from ovens by tong. This conveyance—an industrial chariot on two wheels—became an animating feature of the composition as well as a mobile base. As Smith saw it, *Voltri VI* was "a tong with wheels and two end clouds," *Voltri VII* (fig. 13) was "a chariot ram with five bar forgings," and *Voltri XIII* was "a circus wheel chariot" with, among other things, "cloud parts below and above its tongue."[31] And while they were cooling in the mill awaiting delivery, as Smith's time at Voltri was about to end, something remarkable happened.

27 David Smith, "Report on Voltri," notes concerning work in Voltri, Italy, in 1962. Reprinted in *David Smith 1906–1965*, 335.

28 Ibid. Regarding the work clock, also see "Events in a Life," 22: "All my life the workday has been any any [sic] part of the 24 – on oil tankers, driving hack, going to school, all three shifts in factories. I'd hate to live a routine life. Any 2/3 of the whole 24 are wonderful as long as I choose."

29 Smith, "Report on Voltri," in *David Smith 1906–1965*, 335.

30 Ibid., 337.

31 Ibid.

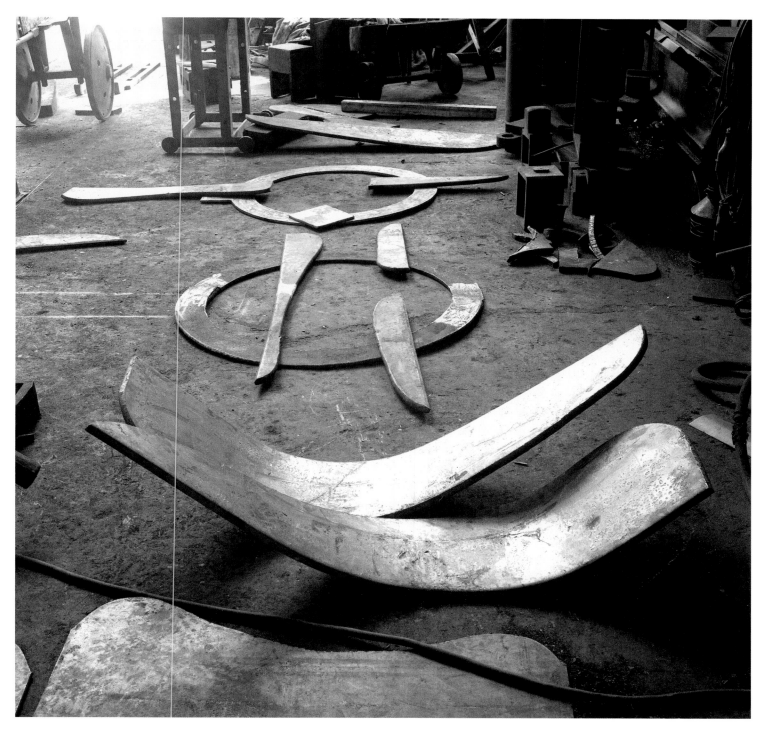

Fig. 10. David Smith, *Voltri XII* and *Voltri XV* (both 1962)
in progress, photographed by Ugo Mulas, Voltri, 1962

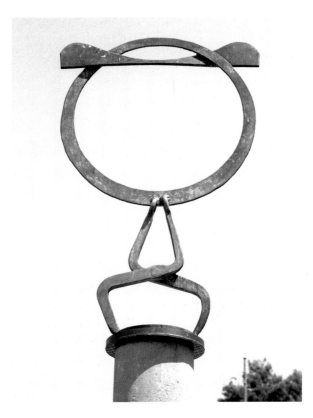

Fig. 11. David Smith, *Voltri II* (1962), photographed by Ugo Mulas, Spoleto, 1962

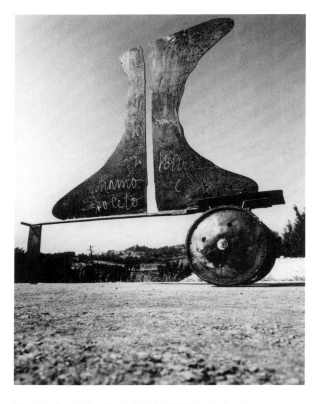

Fig. 12. David Smith, *Voltri VI* (1962), installed in the Roman amphitheater, photographed by Ugo Mulas, Spoleto, 1962

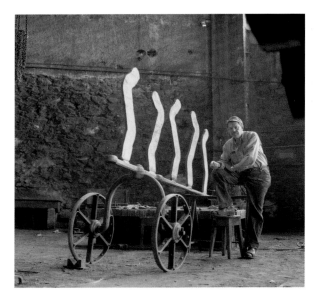

Fig. 13. David Smith with *Voltri VII* (1962) in progress, photographed by Ugo Mulas, Voltri, 1962

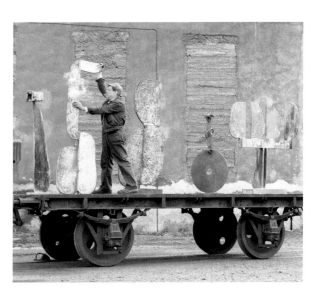

Fig. 14. David Smith on a flatcar outside of the Italsider factory, photographed by Ugo Mulas, Voltri, 1962

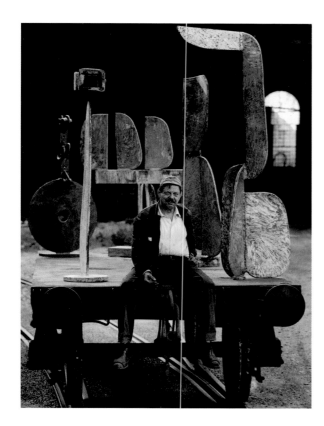

Fig. 15. David Smith with *Voltri III, Voltri V, Voltri IX, Voltri X,* and *Voltri IV* (all 1962), photographed by Ugo Mulas, Voltri, 1962

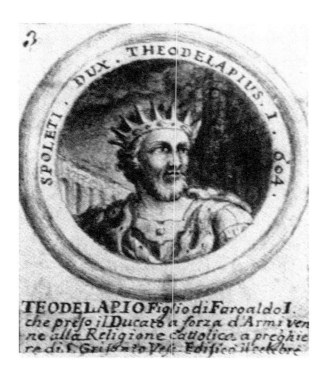

Fig. 16. Duke of Spoleto, illustration published in *I duchi di Spoleto* (Spoleto: Panetto e Petrelli, 1940)

From Voltri's clock, which had governed the work stream of his imagination for the past thirty days, a dream unfolded. Smith's dream started with the defunct railroad flatcar he had collected at Voltri and ended with a whole sequence of flatcars: a flatcar with "vertical sheets," then next one with "nude bodies of machines," then one with "a hundred anvils," and then one with "painted skeletal wooden patterns" (figs. 14, 15). He could see it. What stood between this dream and reality? Smith said Mulas had brought him closest to realization when he photographed the Voltris on the old flatcar. What else was the dream but a longing for mobility? To see the railroad flatcar and a host of others, too old for the tracks—so useless to industry but so essential to art—transported to Spoleto required the dreaming of a different kind of engineer. This is the fantasy that makes him a kindred spirit to Calder. Smith would linger there, if only for a moment, before giving way to the realities of the work cycle. As he said, "In a year I could have made a train. The flatcar I had is now melted in the open hearth and rolled into sheet."[32]

CALDER'S ENTRANCE

Did Calder in a sense live Smith's dream? On August 1, 1962, Calder saw his work arriving by train. Of course, it was Calder who was arriving by train and the artwork (assembled on site) that was waiting for him, poised on all fives astride the traffic roundabout at the station. His recognition of the object's presence would be the true test of animation. That moment was so exhilarating to him that he thought to make a memorandum six days later. He wrote, "I first caught sight of Teodelapio from the train and was delighted at his size and expanse. Dimensions can be deceiving—and I was surprised to learn that the object was taller than it was wide—as I had thought I remembered the contrary."[33] The observation rings with the elation of the inventor finding his own creation alive—actually larger than most life—peaking above the rooftops of Spoleto. It is interesting to note that Calder named the object only after seeing it that day. Standing in the hotel lobby, according to Carandente, Calder noted the simi-

32 Smith, "Report on Voltri," in *David Smith 1906–1965*, 337.

33 Alexander Calder, "Memorandum on Teodelapio," August 6, 1962. Published in Carandente, *Calder*, 226.

larities between the object's shape and the tricorn hat depicted in an old print of Teodelapio, Duke of Spoleto (figs. 7, 16).[34]

Why had its dimensions surprised Calder? With the thirty-by-thirty-inch maquette acting as his proxy, Calder had demonstrated the shape, the proportions, and the clearance of the object for the shipbuilders in charge of its manufacture and enlargement at Savona. As he instructed, "The plates of which it is built should be about 3/8 inch thick, and bolted together, something like a ship (but bolted, not riveted)."[35] He even anticipated that he would add the necessary stiffeners, ribs, and joints once the object was assembled on the site. However, he ultimately left the size of the object unknown. Calder's engineering training had taught him that growing such a thing required special knowledge of the strength and capacity of the metal, and he had relied upon the shipbuilders at Italsider, who knew about nautical-grade steel, to set the multiplier for his own "dreadnought."[36] He recounted, "When I heard that Italsider was multiplying by 27 I was very excited. And I am still excited and delighted."[37]

Calder had always taken delight in the phenomenological world. As a young man, he woke up one morning on the coil of a rope on the deck of a freighter (H. F. Alexander) off the coast of Guatemala, and, upon seeing the sunrise on one side of the deck and the full moon on the other, he received "a lasting sensation of the solar system."[38] This awareness that all was in motion on an earth spinning at a thousand miles per hour complemented his surprise at the final stature of his colossus, apprehended from the moving train.[39] When Calder's memo stated, "Dimensions can be deceiving," he meant it in a good way. It excited him.

Calder did not arrive at the train station that day in August simply for mere excitement, though; he was also coming to the rescue. Curator and museum director James Johnson Sweeney, who had been in town for the festival, had telegraphed his alarm about a very tenuous moment in the assembly of the object. Calder's reply (also by way of telegraph, dated July 24) registered his concern as follows: "LOVE DANGER COMING QUICK."[40]

In 1962, the urgent summons to Calder was less a matter of political history or art history and more a response to a practical crisis resulting from the artist's treatment of the Spoleto sculpture as a true collaboration of imagination between Carandente and himself. The interchange was evident from Calder's earliest correspondence, dated March 27, 1962 (fig. 17). Carandente had wanted a large mobile at the entrance of the city on the road leading to the Rome freeway—as Calder understood it, something to "cover a crossroads entering the town."[41] The sketch in the letter indicates that in Calder's mind the entrance was a gateway—always an arch of sorts.

Three weeks later, he informed Carandente: "Instead of a mobile, I am making you a stabile, which will stand on the ground, + arch the roadway."[42] The image of the accompanying drawing was definitive in both configuration and context, as if in his mind he had already been to Spoleto and walked around the sculpture (fig. 18). As depicted, the object seemed part animal, touching down on five points, arched and in suspense, ready to spring; part landscape in the expansive horizon of its body, spanning the space as it echoed the ridgeline of the mountains against which it was placed; part cityscape in its height, reaching up with arrowed head and blunted tail and resonating with the medieval fortress and the cathedral spires along the hillside of the town (fig. 19).

Once the gigantic steel structure was assembled, the city engineer Oscar Rosini questioned whether Calder's object could withstand Spoleto's winter winds.[43] When Sweeney sounded the alarm, Calder knew that now was the time to follow through with adjustments. The solution for his object's viability in many ways relied upon the most fundamental aspect of his practice: drawing.

The drawings themselves, though fragmented and partial, have a gestural appeal. Like in his early pencil sketches of aerialists in the circus from 1925 (fig. 20), Calder's lines search the page, capturing his object's thrusting planes.[44] Following the direction of the thrust, Calder found opportunities for the application of supportive ribs; at the intersections, just at the points of connection and extension between body and limbs where lines of force cross, he created flanges to occupy

34 Carandente, Calder, 215. Also see Carandente, Teodelapio: Alexander Calder, 63–65.

35 Letter, Calder to Carandente, April 20, 1962, in Carandente, Teodelapio: Alexander Calder, 18.

36 Alexander Calder, Calder: An Autobiography with Pictures, ed. Jean Davidson (New York: Pantheon, 1966), 5.

37 Calder, "Memorandum on Teodelapio," in Carandente, Calder, 226.

38 Calder, Calder: An Autobiography with Pictures, 54.

39 Calder, "Que Ça bouge–à propos des sculptures mobiles."

40 Telegram, Calder to Sweeney, July 24, 1962, in Carandente, Calder, 220.

41 Letter, Calder to Carandente, March 27, 1962, in Carandente, Calder, 216.

42 Letter, Calder to Carandente, April 20, 1962, in Carandente, Calder, 216.

43 Carandente, Calder, 218n9. The account is repeated in Carandente, Teodelapio: Alexander Calder, 61.

44 Calder's drawings for the ribs and flanges for Teodelapio are published in Carandente, Calder, 221–22; and in Carandente, Teodelapio: Alexander Calder, 36–37.

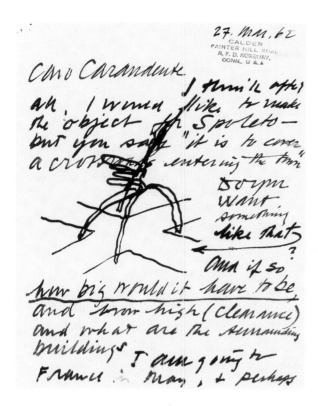

Fig. 17. Letter from Alexander Calder to Giovanni Carandente, March 27, 1962. Archivio Carandente, Serie Calder I 1.2, in Biblioteca G. Carandente, annex of Palazzo Collicola Arti Visive

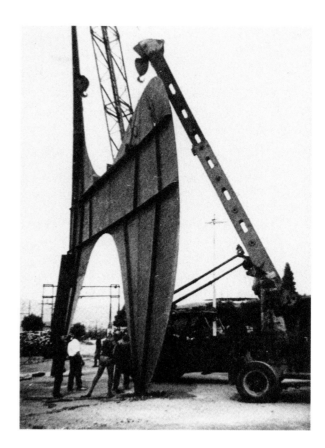

Fig. 19. Italsider technicians erecting the first element of *Teodelapio*. Archivio Carandente, in Biblioteca G. Carandente, annex of Palazzo Collicola Arti Visive

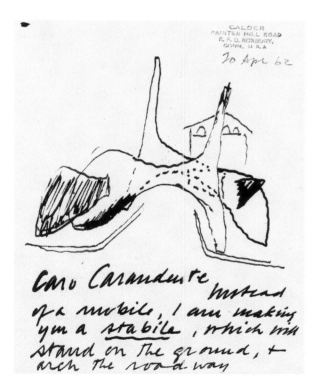

Fig. 18. Letter from Alexander Calder to Giovanni Carandente, April 20, 1962. Archivio Carandente, Serie Calder I 1.2, in Biblioteca G. Carandente, annex of Palazzo Collicola Arti Visive

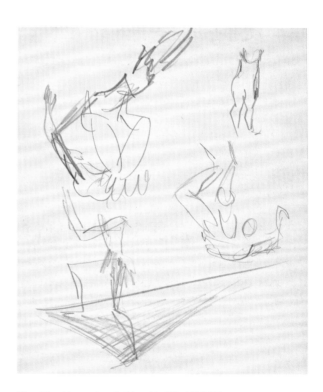

Fig. 20. Alexander Calder, *Untitled* (1925)

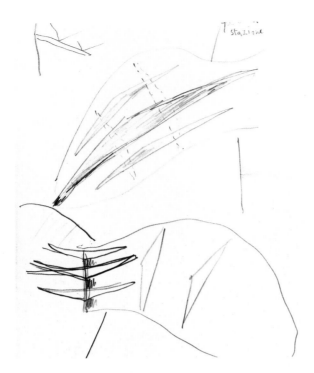

Fig. 21. Alexander Calder, sketch of flanges and ribs. Archivio Carandente, in Biblioteca G. Carandente, annex of Palazzo Collicola Arti Visive

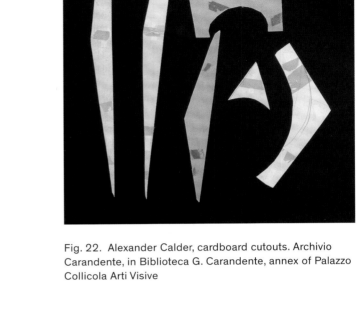

Fig. 22. Alexander Calder, cardboard cutouts. Archivio Carandente, in Biblioteca G. Carandente, annex of Palazzo Collicola Arti Visive

interstitial spaces (fig. 21). These tailor-made shapes of ribs and flanges next became cardboard cutouts (fig. 22).[45] When laid out individually they call to mind materials set at the ready in Smith's workspace, but when taped to the metal maquette the result made for an eloquent grasp of Calder's invention (fig. 23). Here was something pragmatic, easily communicated to the technicians and welders who would be the ones to scale them up and apply them to the final sculpture, so that *Teodelapio* could safely occupy the world in motion around it.

Here, too, is a patterned element of the inventor's fantasy in play that should be recognized—namely, the idea that knowledge, even imaginary knowledge, is social and can be brought into the real world as a process of an open exchange. Throughout the project, Calder's actions—what he communicated as well as when and how—demonstrate a certain confidence in this belief. There may be gaps, near misses, panic, and adjustment, but if the elements are in the right relationships, then in the end the universe will find a new equilibrium—much as John Dewey defined the connection between art and experience (figs. 24, 25).[46]

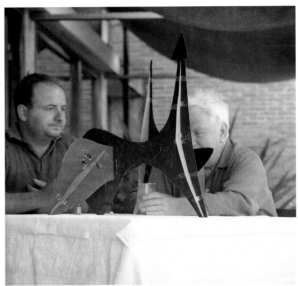

Fig. 23. Alexander Calder (right) and Oscar Rosini with the artist's maquette of *Teodelapio* (1962), taped with cardboard ribs and flanges, photographed by Ugo Mulas

45 The cardboard cutouts are published in Carandente, *Calder*, 220; and in Carandente, *Teodelapio: Alexander Calder*, 35.

46 "Life itself consists of phases in which the organism falls out of step with the march of surrounding things and then recovers unison with it—either through effort or by some happy chance. And, in a growing life, the recovery is never mere return to a prior state, for it is enriched by the state of disparity and resistance through which it has success-fully passed. . . . Because experience is the fulfillment of an organism in its struggles and achievements in a world of things, it is art in germ. Even in its rudimentary forms, it contains the promise of that delightful perception which is esthetic experience." John Dewey, "The Live Creature," in *Art as Experience* (New York: Milton, Balch & Company, 1934), 14, 19.

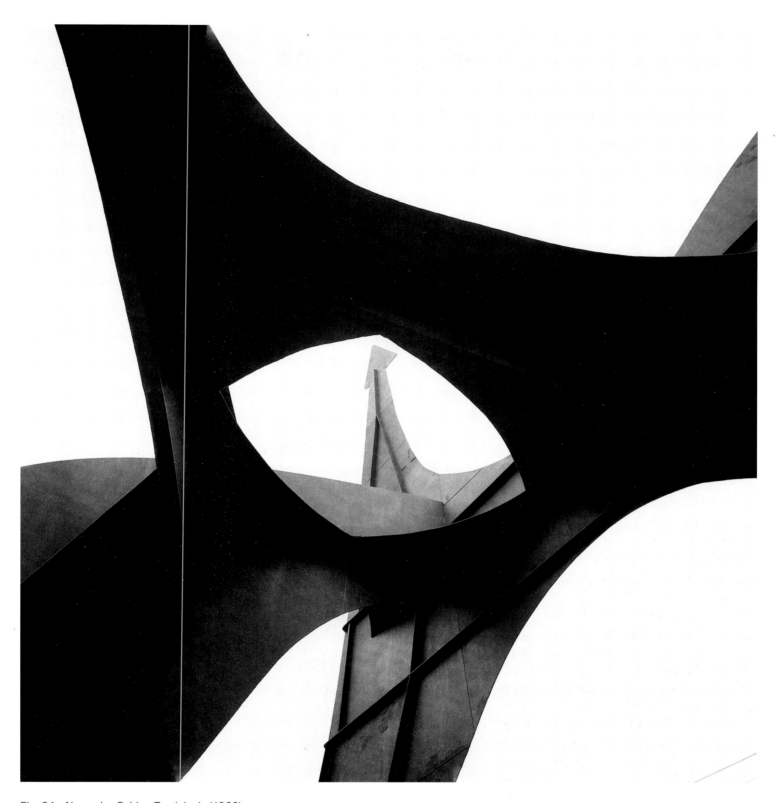

Fig. 24. Alexander Calder, *Teodelapio* (1962),
photographed by Ugo Mulas, Spoleto, 1962

Fig. 25. Alberto Zanmatti, Alexander Calder, and Giovanni Carandente (left to right), who holds maquette II of *Teodelapio* (1962), photographed by Ugo Mulas, Spoleto, ca. 1962

EPILOGUE: INVENTOR'S FANTASY

If radical invention, as Kubler defines it, "plunges artists into universes or new imaginative spheres whose coordinates they alone could disclose,"[47] then we would do well to remember Spoleto, when the tasks at hand propelled Calder and Smith toward ever more sweeping gestures, and where a little-examined but powerfully motivating force, an "inventor's fantasy," revealed itself as a fundamental animator in the work of both artists.

Carandente had bet on these artists because he had seen their work developing apace with the postwar idealistic push toward a "new monumentality."[48] From the European perspective, Americans, by way of habituation with technology or scientific education or factory techniques, essentially had patented their own vocabularies and structures to become masters of such things.[49] What better qualification, then, to undertake this tenet? The roles Carandente assigned in Spoleto were recognizable—

in many ways, they were like the ones the artists had already fashioned for themselves, whether it be artist-engineer (Calder)[50] or artist-welder (Smith),[51] as they turned to the world to explain the unusual objects emerging from a medium with virtually no history.

What permitted Calder and Smith to stand tall in Spoleto—to not be overawed by the shadow of precedent—was the entitlement each felt by virtue of his inventions. It was just this combination of disdain and confidence that allowed these Americans to not waste time on past solutions but instead to launch their respective sculptural practices into untested waters. Augmenting this decision was the clarion call of now—"now was the best time since the world began for the inventor's devotion to new discoveries, or new application of forces known to exist," as it was so plainly written in *The Boy's Book of New Inventions* (1912), which was published during their respective childhoods and accessible to most Americans.[52] This mantra was also invoked at the Art Students League in the pedagogy of Robert Henri, as passed on by Sloan to students such as Calder and Smith: "We are not here to do what already has been done.... In every human being there is the artist, and whatever his activity, he has an equal chance with any to express the result of his growth and his contact with life. I don't believe any real artist cares whether what he does is 'art' or not. Who, after all, knows what art is?"[53] True to this mandate, Calder and Smith not only made new things, but made new ways for things to live in the world.

47 Kubler, *The Shape of Time*, 63.

48 See Siegfried Giedion, "The Need for a New Monumentality," in *Architecture, You and Me: The Diary of a Development* (Cambridge, Mass.: Harvard University Press, 1958). Calder first met Carandente at the gallery L'Obelisco in 1956; see Robert Osborn, "Calder's International Monuments." Carandente most likely saw Smith's work exhibited at the 29th Venice Biennale (US representation: Lipton, Rothko, Smith, and Tobey), June–October 1958. See the website of The Estate of David Smith, accessed April 11, 2017, http://www. davidsmithestate.org/exhibition_history.html.

49 For an analysis of the increasing dominance of things, spawned by invention in modern American life and thought, see Wanda Corn, *Great American Thing* (Berkeley: University of California Press, 2001) and Bill Brown, *A Sense of Things: The Object Matter of American Literature* (Chicago: University of Chicago Press, 2003). I am indebted to David Anfam, who underscored the importance of the object world of Smith's sculptures. See

David Anfam, "Vision and Reach: The World Is Not Enough," in *David Smith: A Centennial*, exh. cat. (New York: Guggenheim Museum, 2006), 21–22.

50 "I could never forget my training at Stevens, for I started experimenting with toys in a mechanical way." Alexander Calder quoted in "Futurist Toys for Advanced Kiddies Created by Calder, Artist-Engineer," *New York Herald*, August 4, 1927, Paris edition, 7.

51 "Before knowing what art was or before going to art school, as a factory worker I was acquainted with steel and the machines used in forging it." David Smith, "The New Sculpture," in *David Smith 1906–1965*, 324.

52 Harry E. Maule, *The Boy's Book of New Inventions* (New York: Doubleday, Page, & Company, 1912), preface, n.p. David Smith vividly recalled growing up in a culture of invention: "My father was an inventor and he invented electric things—coinboxes that you couldn't fill with slugs and things like that. He invented an electric victrola before

they were ever on the market. When I was a kid, everyone in town was an inventor." David Smith, "The Secret Letter," interview by Thomas B. Hess (editor of *Art News*) (June 1964), published in *David Smith*, exh. cat. (New York: Marlborough-Gerson Gallery, 1964). Reprinted in *David Smith 1906–1965*, 343.

53 Robert Henri, *The Art Spirit* (New York: J. B. Lippincott Company, 1923), 226, 16.

I want to thank Sandy Rower, Lily Lyons, Alexis Marotta, Susan Braeuer Dam, Jessica Holmes, and John Sapp at the Calder Foundation and Peter Stevens, Susan Cooke, and Caroline Nelson of The Estate of David Smith for their help with essential documents and invaluable suggestions. I also am extremely grateful to Emily Turner, Larry Goedde, Chelsea Taylor, and Jessica Holmes for reading various drafts, and to Frances Malcolm. Also, I want to thank Dan Weiss and Lucia Colombari at University of Virginia, whose help with the illustrations has been invaluable.

Ugo Mulas and the Photography of Modern Sculpture

Sarah Hamill

The dialogue between a sculptor and his photographer comes from private conversations and documents the ambiguity, the difficulty, the pain, the joy and happiness of making art.

 —Umberto Eco, introduction
 to *Fotografare l'arte*, 1973

Toward the end of his life, the Italian photographer Ugo Mulas wrote a treatise about what he saw to be the essential concepts of photography. Titled "Verifications" (1970), the photo-essay explores the medium's operations, arguing for an understanding of photography as a pragmatic philosophy of vision.[1] The basic controls and processes of loading the film, focusing, composing, and taking the picture, and enlarging and cropping are scrutinized and disassembled so as to "verify their use and function."[2] Here, too, Mulas reflects back on what had become his signature trope: portraits of artists that brought to life the creative process. "Verifications" (11) recounts Mulas's session with the Italian sculptor Arnaldo Pomodoro in his studio:

I asked [him] to pose among his things in the studio, leaving everything there at the time at the same place, including sprays, pots and tins, teacups, wine bottles, rags, clothes, just started, finished or broken sculptures, drawings rolled up on the floor or hung on the wall, everything that is usually found in a studio. Well, these things live in this enormous space, things having a relationship with the person living in the studio; photographing an artist among all these things, especially if he is not in the foreground but halfway in between … means demythologizing him, making him more human—or, better, not more human, but rather showing his condition of human being, that of any human being with all his problems.[3]

In this passage, Mulas identifies the ambitions behind his approach: by situating the sculptor within the sprawling studio, he could accentuate the bodiliness of making. Sculpture here emerges out of human activities; it is drawn from the things and materials of what is a homely and everyday space. Mulas thus rejected an approach to portraiture that mythologized the artist as a master-genius in a static or timeless image—a photographic style crystallized in Edward Steichen's 1902 portrait of Auguste Rodin contemplating *The Thinker*. Unlike Steichen's portrait, which elevates the artist to an intellect divorced from the craft of making, Mulas's portraits position the artist in the midst of creation, surrounded by raw materials.

In 1962, Mulas actualized this photographic style when he photographed Alexander Calder and David Smith during a period in which both artists also radically changed their approach to sculpture.[4] Mulas had documented the Venice Biennale since 1954 using a broad technique that presented the life of the festival. But it was in 1962, when the curator and critic Giovanni Carandente invited Mulas to document Calder's and Smith's work, that he began developing an approach to portraiture that stressed the tangible acts of making. It was a pivotal year for Calder and Smith. Both were invited to participate in the Festival of Two Worlds, held annually in Spoleto, a small medieval town in Umbria, which included an exhibition of sculptures by European and American artists, now commonly known as *Sculptures in the City*.[5] Carandente, the exhibition's curator, worked with the Italian steel corporation Italsider to invite artists to make works in steel mills across Italy. Calder and Smith both participated—as did Beverly Pepper, Lynn Chadwick, Carlo Lorenzetti, Pomodoro, and others.[6] For Calder and Smith, two stalwarts of modernism who radically redefined sculpture with welded steel objects or constructions that were drawings in space, the Italsider collaboration was an opportunity to work in innovative ways. They found themselves creating sculptures in a new colossal format or as an ambitious set of objects staged in dynamic ways in dialogue with the city—all achievements that Mulas's photographs helped to publicize to a broad audience. Indeed, it was through Mulas's photography, disseminated widely in magazines and books at the time, that these two sculptors enjoyed a newfound and widespread appeal in the 1960s.

For his part, Calder designed a monumental sculpture that was to be installed in a public

1 Germano Celant, "Photographic Scores," in *Ugo Mulas*, ed. Germano Celant, trans. Anna Coffetti (New York: Rizzoli; Milan: Federico Motta Editore, 1989), 11.

2 Ibid.

3 Ugo Mulas, "Verifications" (11), in *Ugo Mulas*, ed. Celant, 11. For a discussion of Mulas's "Verifications" within the context of the history of photography, see Jean-François Chevrier, "The Adventures of the Picture Form in the History of Photography," in *The Last Picture Show: Artists Using Photography 1960–1982*, ed. Douglas Fogle, exh. cat. (Minneapolis: Walker Art Center, 2003), 121.

4 That year he also documented Alberto Giacometti installing his sculptures at the Venice Biennale.

5 See Giovanni Carandente, *Sculture nella città: Spoleto 1962*, English-Italian edition (Spoleto: NE Editrice, 2007), 7–15.

6 Calder had also been to Spoleto in 1958.

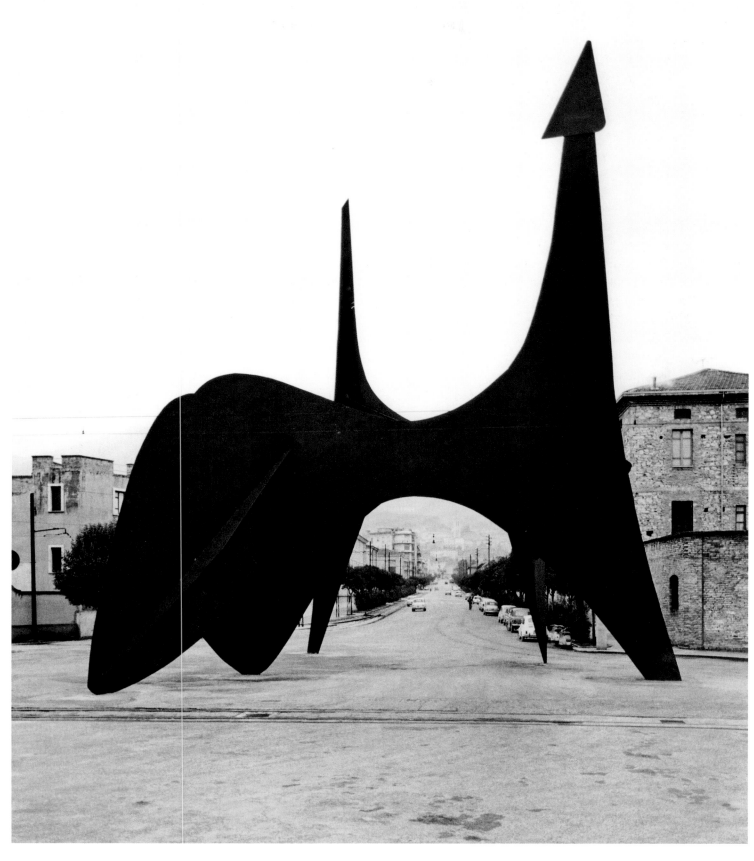

Fig. 1. Alexander Calder, *Teodelapio* (1962),
photographed by Ugo Mulas, Spoleto, 1962

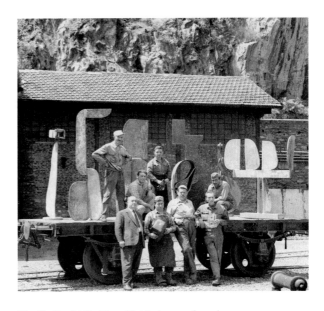

Fig. 3. David Smith with his team of workers,
photographed by Ugo Mulas, Voltri, 1962

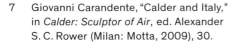

Fig. 2. Alexander Calder with workers standing under
Teodelapio (1962), photographed by Ugo Mulas, Spoleto, 1962

square at the train station outside Spoleto (fig. 1).
This work joined his 1959 sculpture *Black Widow*,
installed elsewhere in the city as part of the exhibi-
tion. Carandente had initially approached Calder
to design a work for the entrance to the exhibition;
Calder responded by creating a maquette for a skeletal
body anchored on five points, with two arcing necks
that swept up into the sky. He sent the maquette to
the Italsider plant in Savona, Italy, where skilled
workers enlarged it twenty-seven-fold in sheet metal
of the sort that was used in wartime shipbuilding—
unusually large sheets of steel.[7] The pieces were trans-
ported to Spoleto and welded on site (fig. 2).[8] Titled
Teodelapio after a medieval Lombard duke—Calder
thought the sculpture bore a resemblance to a tricorn
hat worn by the duke in a print he saw and was
drawn to[9]—it is a colossal work, approximately sixty
feet high, that towers above its architectural and
human surroundings (see fig. 1). *Teodelapio* is also a
"stabile," a word Hans Arp used in 1932 to refer to

Calder's motionless sculptures, but it represents
a new mammoth size, in part made possible by the
Italsider factory. The work was among the first
gargantuan public stabiles the sculptor would make—
inaugurating a new relationship to urban space and
a new size for sculpture.

Smith's creative production was also radically
transformed by the opportunity to work in collabo-
ration with Italsider. Festival founder Gian Carlo
Menotti, the artist recalled, proposed that Smith
make two sculptures at a company factory over the
course of one month; as his site, Smith chose
the abandoned factory in Voltri, a town just west of
Genoa. With assistance from a staff of six skilled
workmen, he also began working on a larger scale and
at a faster pace, producing twenty-seven sculptures
that incorporated scraps of steel, abandoned tools,
and leftover parts of machines from other Italsider
factories (fig. 3). As Carandente described it, Smith
drew from the scrapheap "skeletons, relics of the flesh
of steel, inanimate forms that had, not long before,
been living symbols of the latest Iron Ages."[10] Several
days a week, a salvage crew would harvest this left-
over material to "feed the melt at Cornegliano," as
Smith said in his "Report on Voltri," and the sculptor
hurried to rescue these materials before the crews
arrived. Smith used these pieces in his Voltri series of
sculptures as well as in what he would title his Vol-

7 Giovanni Carandente, "Calder and Italy,"
 in *Calder: Sculptor of Air*, ed. Alexander
 S. C. Rower (Milan: Motta, 2009), 30.

8 During the installation, Calder traveled to
 Spoleto to design additional footholds
 for the sculpture to ensure it weathered the
 inclement climate. See ibid.

9 Ibid.

10 Giovanni Carandente, "The American
 Odysseus of Sculpture," in *David Smith in
 Italy,* ed. Giovanni Carandente (Milan:
 Edizioni Charta, 1995), 19.

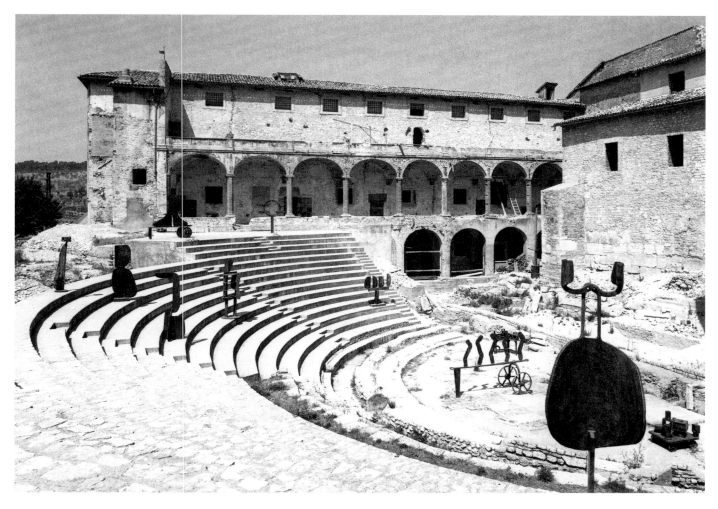

Fig. 4. David Smith's sculptures installed in the Roman amphitheater, photographed by Ugo Mulas, Spoleto, 1962

tron and Voltri-Bolton series, made from the factory scraps and sculptures-in-progress he shipped back to his studio in Bolton Landing, New York. When it came time for installation, Carandente had the ingenious idea to stage the Voltri sculptures in Spoleto's reconstructed Roman amphitheater—he said it was an overflow site for the unexpectedly large number of works Smith had produced (fig. 4). But the setting became more than this, and the textured stones of the Roman theater served as a foil for abstract steel sculpture. Ancient was juxtaposed with modern; classical antiquity, with the antiquity of the machine age. The site became a way for Smith to animate his sculpture.

Mulas was on hand to document these dramatic shifts. His approach was unconventional. Rather than

documenting sculpture using all the usual tropes—in which the object would be positioned against a neutral background, divorced from its context—Mulas found ways of integrating sculpture within its milieu. Take, for a start, his photographs of Calder working in his studio. Before the Spoleto installation, he traveled to the French village of Saché to photograph Calder's second house and studio (the sculptor also lived and worked in Roxbury, Connecticut), and returned several times through the 1960s. The resulting photographs were published in 1971 in an extraordinary monograph Mulas also designed. In these photographs, we see Mulas structuring an intimate encounter with the artist and his work. In several images, he uses the camera to dramatize a sculpture's size. Picturing a maquette of *Les Triangles*

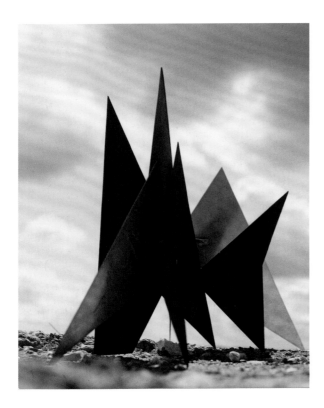

Fig. 5. Alexander Calder, maquette of *Les Triangles* (1962), photographed by Ugo Mulas, Saché, 1963

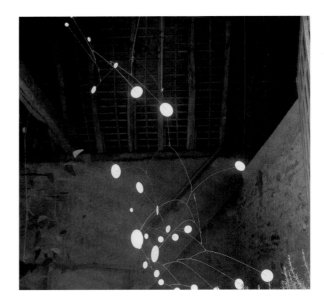

Fig. 7. Alexander Calder, *Snow Flurry* (1948), photographed by Ugo Mulas, Saché, 1963

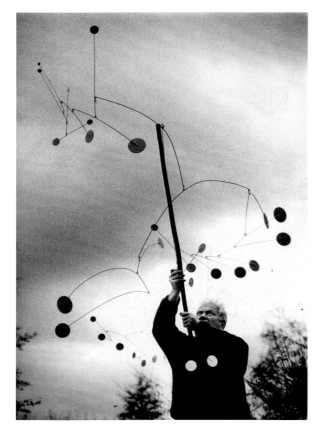

Fig. 6. Alexander Calder and his *Snow Flurry* (1948), photographed by Ugo Mulas, Saché, 1963

(1962) (fig. 5)—an image that evokes the maquette of *Teodelapio*, taken the year after the Festival of Two Worlds—he positioned his camera on the earth, and the extremely low vantage point projects the sculpture against the sky. Here Mulas used photography to imagine the monumental size of the work, borrowing a strategy that photographer Herbert Matter had used to present Calder's sculpture and one that sculptor Henry Moore also used to document his sculpture.

Mulas also took numerous photographs of Calder working amid the ordered disorder in his studios at Roxbury and Saché. The artist himself described his Roxbury studio this way: "It got a little cluttered, although it was not difficult for me to find things I wanted. The mobiles were generally arranged on a system of pulleys which I could lower as they were needed."[11] The photographer situated Calder within this array of materials—hammering, cutting, or arranging metal parts while wearing his handmade visor, or reaching to the ceiling with a wooden pole to move his mobiles. In one photograph from 1963 (fig. 6), Mulas presents Calder outside, his arms reaching to lift the 1948 mobile *Snow Flurry* into the air. The mobile unfurls across the photographic plane; its circles are positives set against the cloud-filled sky. In another shot that faces this one in the 1971 photo-book, the same sculpture is now

11 Alexander Calder quoted in H. Harvard Arnason and Ugo Mulas, *Calder* (New York: Viking Press, 1971), 17.

hung against the opening of a darkened interior—a semi-uniform plane of dark gray that is broken only by the leaves of a rosemary plant in the lower right-hand corner (fig. 7). *Snow Flurry*'s circles now become luminous voids of light set against a flat plane.

In these photographs, Mulas finds innovative ways to use a fixed and static medium to envision mobility—or how Calder's sculptures move between dense obdurate matter and fluid motion. Jean-Paul Sartre described this duality in 1946 when he recounted being in Calder's studio at the moment

> *a mobile, which had until then been still, became violently agitated right beside me. I stepped back and thought I had got out of its reach. But suddenly, when the agitation had left it and it seemed lifeless again, its long, majestic tail, which until then had not moved, came to life indolently and almost regretfully, spun in the air and swept past my nose. These hesitations and resumptions, gropings and fumb-lings, sudden decisions and, most especially, marvellous swan-like nobility make Calder's mobiles strange creatures, mid-way between matter and life. . . . It is one, one single bird. And then, suddenly, it breaks apart and all that remain are rods of metal traversed by futile little tremors.*[12]

Sartre's account of the awkward transition between stillness and motion, between the thingness of sculpture and the kinetic fluidity of the mobile, speaks

to Mulas's pair of images. On the one hand, the mobile is seen as a cumbersome thing, laboriously held aloft by the body of the sculptor; on the other, it is a set of two-dimensional abstract shapes that seem to glow from within—an otherworldly image with a movement of its own. Here Mulas finds a different language for describing a mobile's kinetic qualities from the one Herbert Matter used in his "Mobiles in Motion" series of photographs, taken around 1939 (fig. 8). Matter employed strobe lights to map a mobile's movements in time in a single photographic plate, a technique evocative of the cyclographs used by Frank Gilbreth to study workers' bodies in motion in the 1910s.[13] Sculptural motion is mapped in time, fixed in a single image, which, as scholar Marko Daniel has argued, brings into "opposition the notions of change and sameness; of rupture

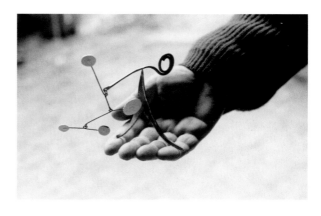

Fig. 9. Alexander Calder holding *Untitled* (ca. 1964), photographed by Ugo Mulas, Saché, ca. 1964

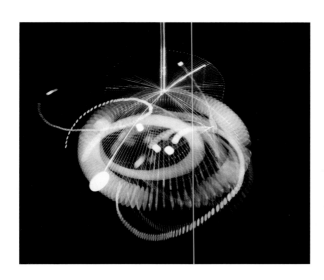

Fig. 8. Alexander Calder, *Untitled* (1936) set in motion, photographed by Herbert Matter, ca. 1939

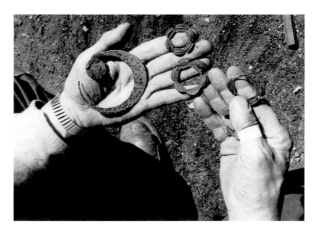

Fig. 10. David Smith holding parts of his works, photographed by Ugo Mulas, Voltri, 1962

12 Jean-Paul Sartre, "Les Mobiles de Calder," in *Alexander Calder: Mobiles, Stabiles, Constellations*, exh. cat. (Paris: Galerie Louis Carré, 1946), 9–19. Translation by Chris Turner from a compilation of essays by Sartre titled *The Aftermath of War* (Calcutta: Seagull, 2008).

13 On Frank Gilbreth's photography, see Marta Braun, *Picturing Time: The Work of Etienne-Jules Mary (1830–1904)* (Chicago: University of Chicago Press, 1992), 343–48.

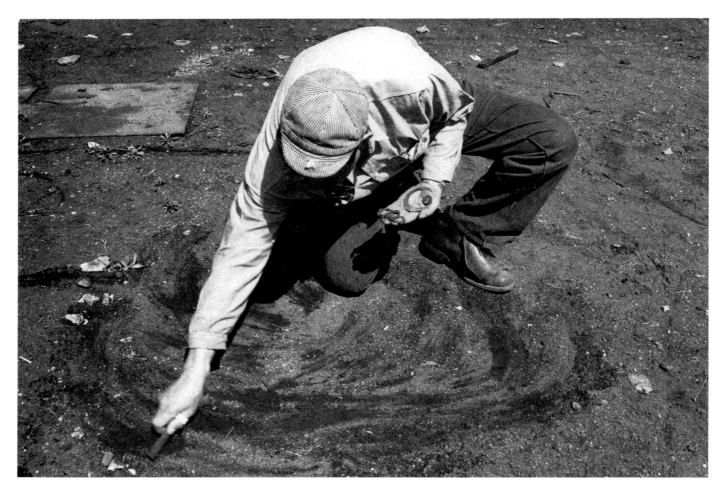

Fig. 11. David Smith at work, photographed by
Ugo Mulas, Voltri, 1962

and torpor; progress and stagnation ..."[14] Mulas, by contrast, used light and shadow to point up the three-dimensionality of Calder's works—as in his photographs of the wire sculptures, which use light to bring to life the sculpture seen in space.

Mulas also stressed the physical labor of making sculpture with several portraits of the artist's hands. In one taken around 1964 (fig. 9), Calder holds a small standing mobile in his palm. Slender, linear, and tiny, the sculpture seems precariously positioned, at odds with the heft and wear of Calder's thick fingers. In this photograph, a delicate sculpture of the machine age is contrasted with the human hand that made it, which itself seems sculptural since the photograph, using light, points up the indentations and volumes of the finger joints. Here sculpture is seen to be a bodily thing; not an optical or linear medium, it is

spatial and physical, something made to be felt, touched, or held in the hand.

This photograph is in dialogue with a series of images that Mulas took of Smith's hands at Voltri. Mulas points his camera down at Smith's palms, which display five circles of metal the artist found in the factory, unearthed from the dirt floor (fig. 10). His hands are weathered and worn—his right thumb is wrapped with protective tape at the joint. In a contact print from the sequence of shots from which the hand photograph was chosen (fig. 12), Smith holds the pieces of metal and draws in dirt a large circle around his body, digging to find forgotten, rusted scrap (fig. 11). Here sculpting is shown to be both two- and three-dimensional, and a process of drawing and finding, feeling the worn bits of metal. In this same contact print, we see how Mulas photo-

14 Marko Daniel, "Between Paris and New York: Fountains, Fluidity, Politics," in *Alexander Calder: Performing Sculpture*, ed. Achim Borchardt-Hume, exh. cat. (New Haven, Conn.: Yale University Press; London: Tate Publishing, 2015), 52. See also Jed Perl, "Spirit Photographs," in *Calder by Matter* (Paris: Cahiers d'Art, 2013), 190.

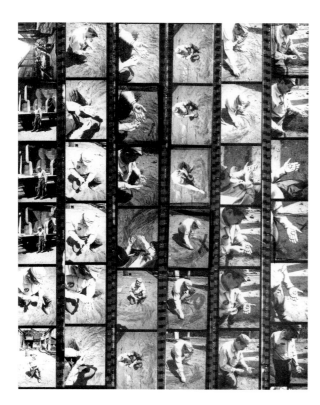

Fig. 12. Contact prints of David Smith at work, photographed by Ugo Mulas, Voltri, 1962

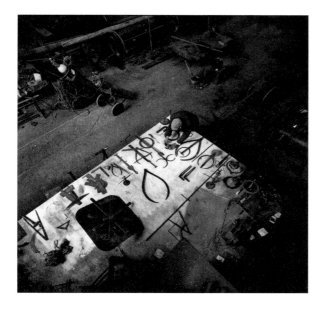

Fig. 13. David Smith at work, photographed by Ugo Mulas, Voltri, 1962

graphs the sculptor performing an archaeology of sorts, excavating the buried remains of modernization from the factory floor.[15] But it is the close-up frame of the sculptor's hands that Mulas chooses as one of the shots for reproduction as a synecdoche for the tactile and physical labors of making.

Moving from close to the ground to high up within the Italsider factory, Mulas also positioned his camera from a scaffolding looking down at the table Smith used to lay out compositions of his work (fig. 13). As the sculptor explained in his "Report on Voltri," he had the table painted with lime and water, giving it a white tone—a background for his steel forms that echoed the white patches he painted on the floor of his Bolton Landing studio. Mulas used the aerial view to dramatize Smith's working methods as the artist manipulates steel parts, arranging and rearranging them into compositions. Here sculpture is shown to be a contingent process of testing out arrangements, a makeshift drawing that would later be solidified and made permanent by the weld. In still other photographs Mulas took at Voltri, Smith draws on the factory floor, shifts works into place with his hands, builds temporary constructions with found pieces of metal, or holds open a page of his sketchbook. In these diverse images, the photographer presents Smith's processes of making as bodily and provisional, and one that moves fluidly between two and three dimensions.

These photographs, published widely in the 1960s, joined other photographs showing Calder's and Smith's sculptures installed in Spoleto—images that dramatize the interplays between modern steel sculpture and the everyday life of a medieval town. In one suite of images, Mulas compared Calder's *Black Widow* (1959) to members of the clergy—the sculpture was installed just outside the Dominican church and convent (fig. 14). Locating his camera at the ground, Mulas flattens the sculpture's contours so that they cut into the medieval architecture behind them. He juxtaposes the black habits of the nuns and the dark cloaks of the Dominican priests with the abstract elements of the sculpture. Mulas makes the religious body over into a kind of sculpture—together they form a set of empty shapes cast against the ground.

15 For a discussion of Smith's archiving of modern industry, see Anne M. Wagner, "David Smith: Heavy Metal," in *A House Divided: American Art since 1955* (Berkeley: University of California Press, 2012), 103.

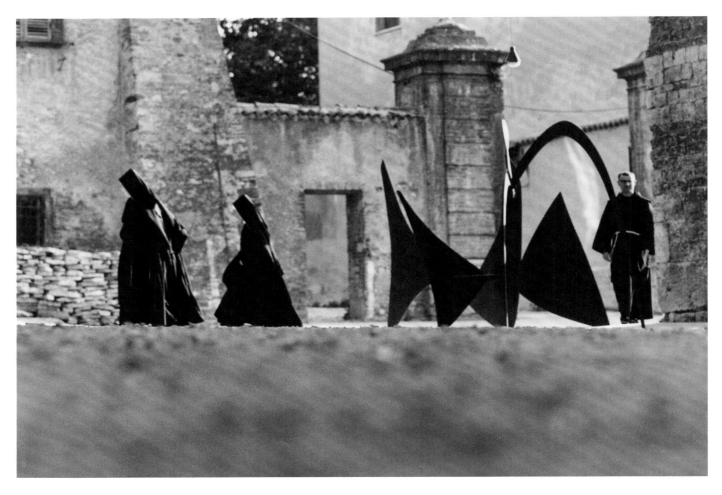

Fig. 14. Nuns passing by Alexander Calder's *Black Widow* (1959), photographed by Ugo Mulas, Spoleto, 1962

Mulas's photographs of Smith's Voltri sculptures staged in the ancient Roman amphitheater, taken during the day and night, dramatized Smith's work; published in the 1960s, these photographs introduced Smith's wide-ranging steel sculptures to a broad audience (see fig. 4). Scattered throughout the archaeological ruin, from the upper steps down onto the stage, the Voltri register as an army of individual and curious objects, each one different from the next—they show Smith's wide experimentations of what sculpture could be: a chariot, a figure, a worktable. Mulas maps these diverse forms in the ruin of the amphitheater as a way to show Smith's sculptures to be animate things—objects that move between human and machine, figure and sculpture. Steel sculpture, emergent from the scrap heap at Voltri and commanding the arena, is presented here as an evocative and deeply spatial monument to

modernism. Here the machine is reanimated in figural form. Mulas also dramatizes Smith's sculptures in one-on-one shots, whether by using the low point of view that was evocative of Smith's own photographs of his sculptures, or by closely cropping them so that the sculptures seem like otherworldly forms in this human setting.[16]

Mulas also used unusual vantage points to dramatize the comparisons between steel sculpture and the life of Spoleto. Adopting a strategy common in New Vision photography of the Bauhaus, he used a disorienting low point of view, pointing his camera up at *Cubi IX* (1961) so as to set it against a clock tower. The burnished, luminous steel cubes of Smith's sculpture are opposed to the worn matte blocks of stone. Here Mulas explores the modernity of the work juxtaposed with the ancient structure. Smith himself was drawn to this presenta-

16 See Sarah Hamill, *David Smith in Two Dimensions: Photography and the Matter of Sculpture* (Oakland: University of California Press, 2015).

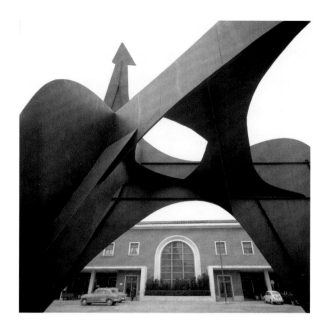

Fig. 15. Alexander Calder, *Teodelapio* (1962), photographed by Ugo Mulas, Spoleto, 1962

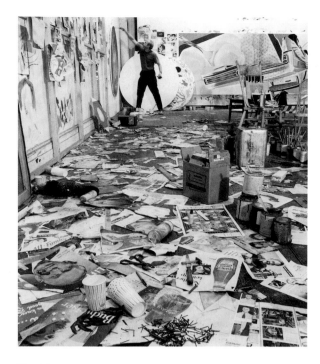

Fig. 16. James Rosenquist, photographed by Ugo Mulas, New York, 1964

tion, and in his "Report on Voltri," he noted how *Cubi IX*, a sculpture he had shipped from the United States to Italy before the exhibition, played off the "soft variables of the [medieval] church wall stones," which Carandente chose as a backdrop to the work.[17]

Unusual vantage points also figure in Mulas's photographs of *Teodelapio*. In one shot (fig. 15), Mulas positioned his camera beneath the hulking sculpture, so that the work is both flattened into a two-dimensional, abstract shape and made into an architectural frame for the train station seen behind it. Mulas maps the sculpture using these two modes in still other photographs of *Teodelapio*, making it over into an abstract plane of dark forms set against a light sky or, alternatively, monumentalizing it as an otherworldly form that towers above the town (see fig. 24 on page 25 and fig. 7 on page 16). We move between images of the sculpture as flattened picture and massive thing, anticipating the photographs of *Snow Flurry* that Mulas would make the following year. The photographs enable us to imagine moving under and through the sculpture, as if seeing it in space.

In each of these heterogeneous photographs, Mulas creates an argument for viewing sculpture within its surroundings. His unexpected juxtapositions and unfamiliar vantage points had the effect

of inviting a beholder to see the sculpture as both bodily shape and abstract form, both an obdurate thing in the medieval town and a two-dimensional image. These modes cannot be disconnected from Mulas's portraits of the two artists at work. In these sequences, we get a sense of Calder's and Smith's processes as haptic ones—they are touching, feeling, holding sculpture, or using their bodies to move it into place. Not a cerebral or purely visual activity, making sculpture demands a tactile sense. This is why Mulas envisions the artists rooted within a space of creativity, amid a spate of raw materials waiting to be manipulated, in scenes we are invited to only voyeuristically observe, thanks to the photographer's unique ability not to intrude.

Mulas's 1962 vision—which showed a new way of thinking about the creative process and about what sculpture could be as a bodily and spatial medium—crystallized his approach to artists' portraits in the 1960s. In *New York: The New Art Scene* (1967), a compilation drawn from images he took on a 1964 trip to the United States, Mulas positioned the figure of the artist surrounded by the personal clutter of the studio, and often at work. James Rosenquist appears in the background of one shot—the camera,

17 David Smith, "Report on Voltri," in *David Smith*, ed. Garnett McCoy (New York: Praeger, 1973), 162.

pointed down, focuses on the studio floor, a sea of magazine clippings, trash, scissors, nails, and paint (fig. 16). To picture Kenneth Noland, Mulas stood outside his studio looking in through a window, so that the artist is figured in a luminous but distanced space—in a space of contemplation that is separate from ours. In these photographs, we are voyeurs who observe the creative practices of making—invited to study, but not to enter, a result of Mulas's ability to recede from view.[18] This signature trope—deepened through the 1960s—began with Calder and Smith in 1962.

As Umberto Eco argued in a 1973 essay, Mulas's approach was a form of art criticism. Like writing, Mulas's photographs make claims about what sculpture's place in the world is or should be—it is both surface and shape, a flattened plane and a concept, as well as a body to be encountered in relation to our own. These images also open onto a new understanding of Calder's and Smith's work at this moment in their careers, animating or making human their sculptures by connecting them to an urban or bodily sphere. Perhaps it was for this reason that Mulas's photographs were championed by both artists. On receiving the photographs in December 1962, Smith called them "terrific."[19] Calder, for his part, wrote to Mulas in 1963 requesting photographs for use in an upcoming exhibition catalogue, calling them "extraordinaires."[20] Mulas's photographs circulated widely in the 1960s, and his vivid images were so much a part of how these stalwarts of modernism were known at this moment in their careers: as artists who were changing the medium by creating colossal public objects and by forging a new identity for sculpture as situated between the human and the machine. Mulas made their processes of making visible, helping the public understand what this new sculpture meant, as a material and physical thing.

18 Mulas's photographic strategy echoes Robert Frank's; Mulas first saw Frank's photography in 1958, ultimately meeting him in 1964 on his trip to the United States. According to scholar Elio Grazioli, when the two met, they discussed how a photograph should entail a quality of distance or impersonality, or how the viewer should not "enter" the photograph. The ironic detachment and cool impersonality of Frank's book *The Americans* (1958) must have appealed to Mulas as a way to wordlessly document the activities of making as an outsider. Mulas also described his encounters with artists as taking place silently. "I went through the Studios without speaking English at all, just saying those few essential words, trying not to be an hindrance or being heard or, yet, hampering what the artists were doing during their work." See Elio Grazioli, "Ugo Mulas: Inside Photography," as published on the website of the Ugo Mulas Estate, accessed May 2, 2017, http://www.ugomulas.org/index.cgi?action=view&idramo=1090230112&lang=eng.

19 Letter, David Smith to Ugo Mulas, December 18, 1962. David Smith papers, Archives of American Art.

20 Letter, Alexander Calder to Ugo Mulas, September 21, 1963. Calder Foundation archives. Mulas would continue to photograph their studios through the 1960s and would take on new commissions and projects documenting sculptors at work. Garnett McCoy, for instance, the Archives of American Art curator responsible for commissioning Mulas to create a "pictorial record" of Smith's house and studio soon after Smith's death in 1965, was so pleased with the results that he sponsored another project with Mulas to photograph Louise Nevelson's studio. See Garnett McCoy, "Photographs and Photography in the Archives of American Art," *Archives of American Art Journal* 12, no. 3 (1972): 11.

Alexander Calder / David Smith

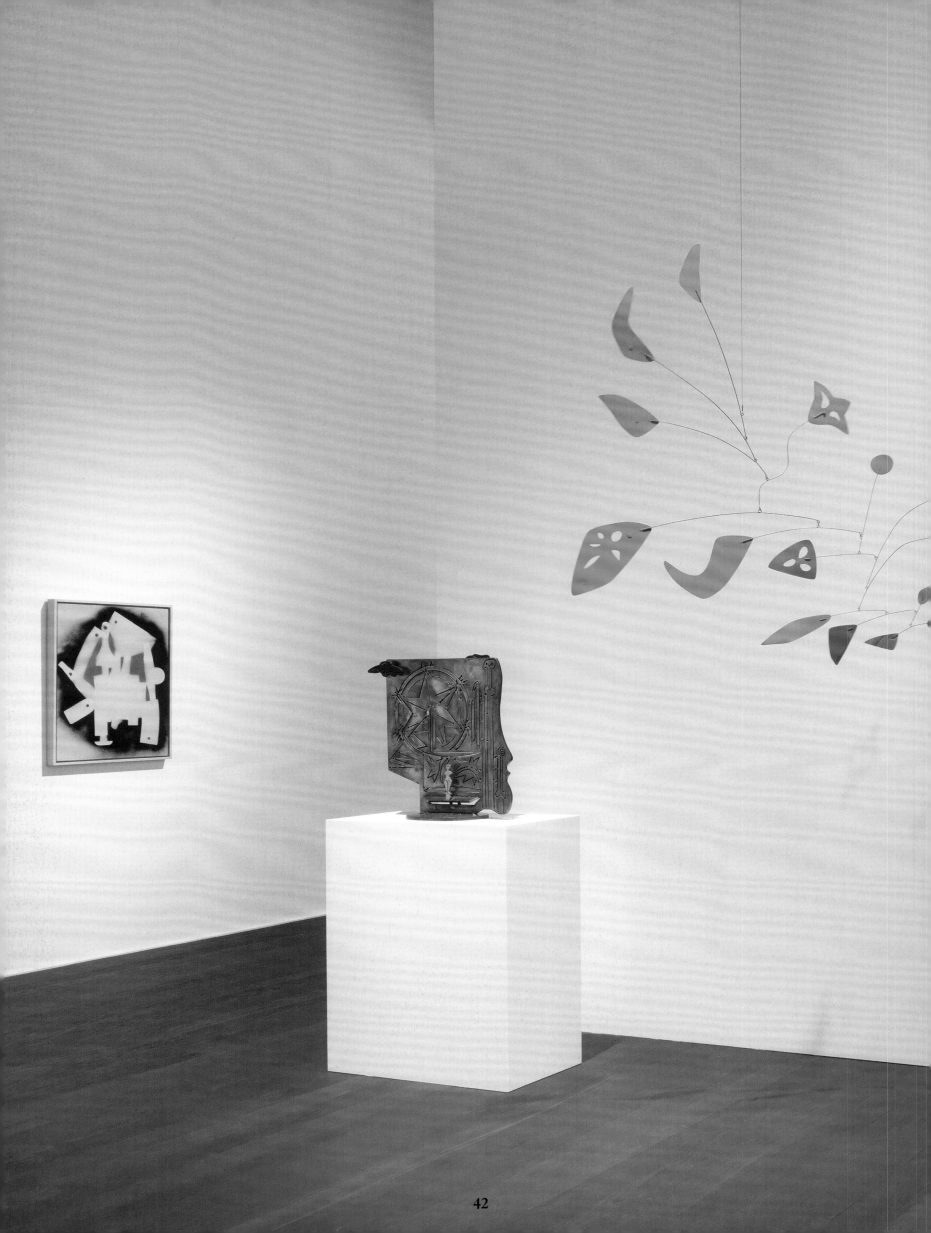

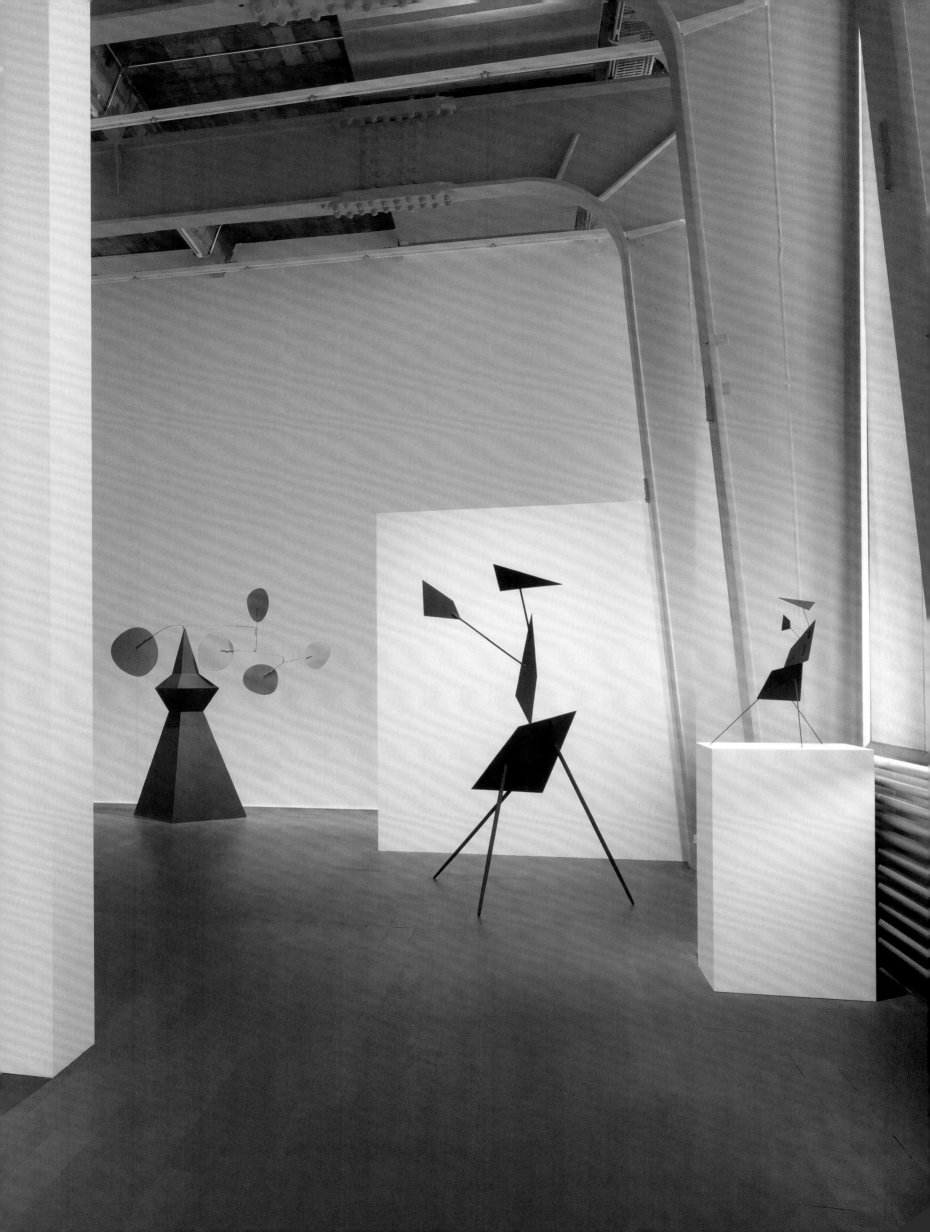

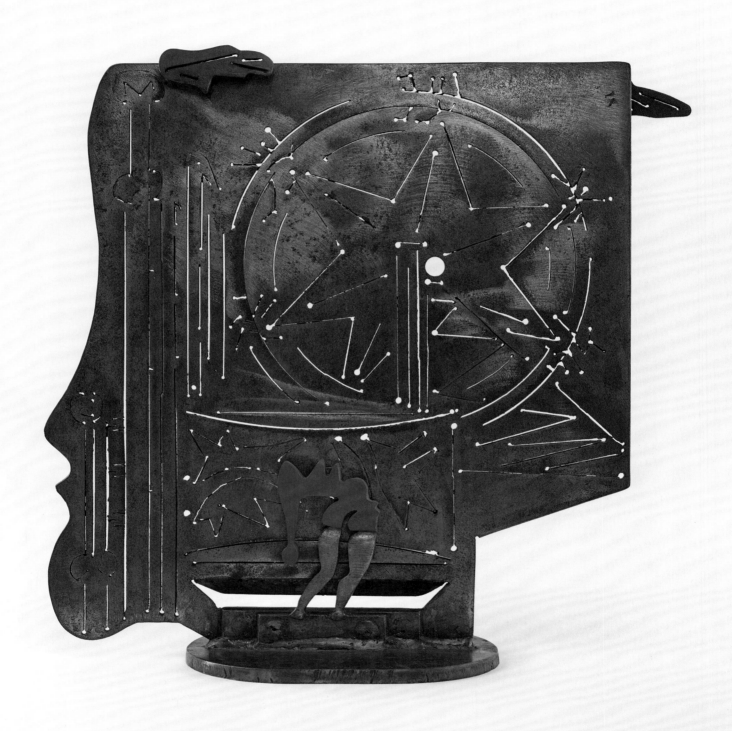

David Smith
Steel Drawing II
1945

Alexander Calder
Red Flowers
1954

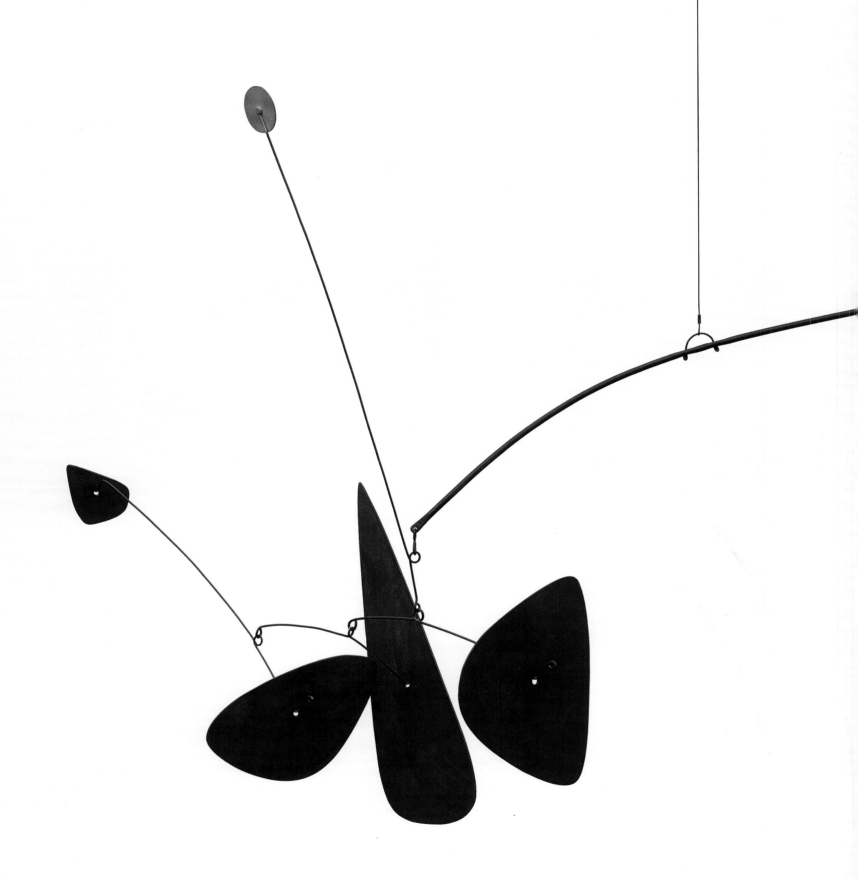

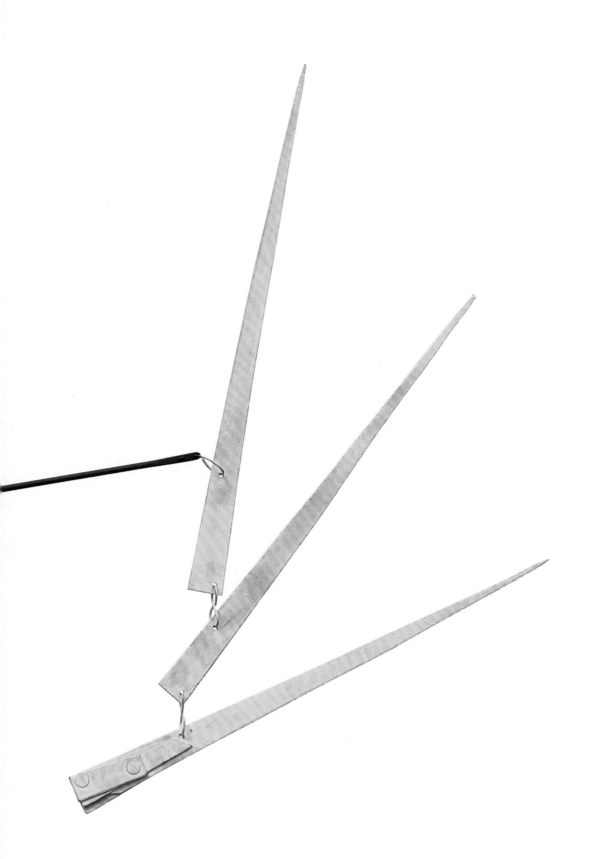

Alexander Calder
Untitled
1943

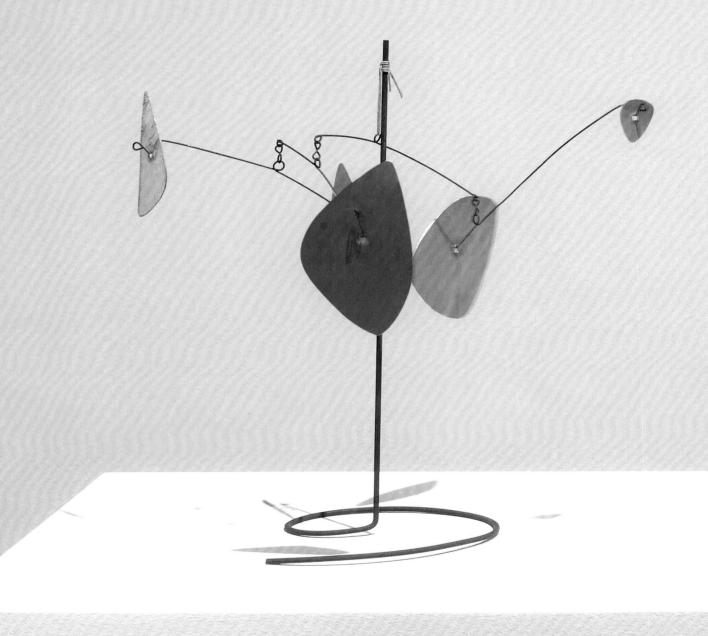

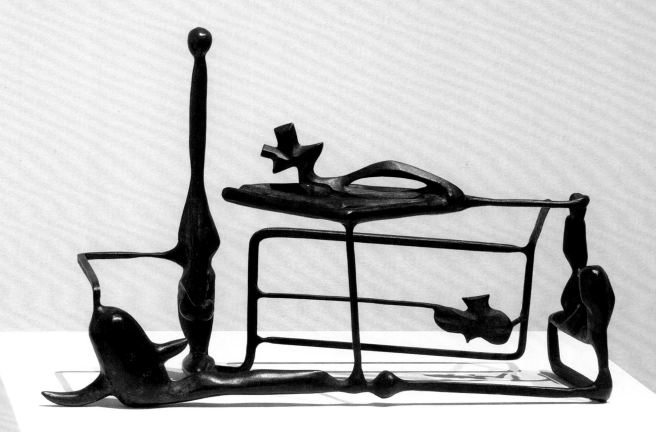

Alexander Calder
Untitled
ca. 1942

David Smith
Objects Left at the Iron
Works in Brooklyn
1942

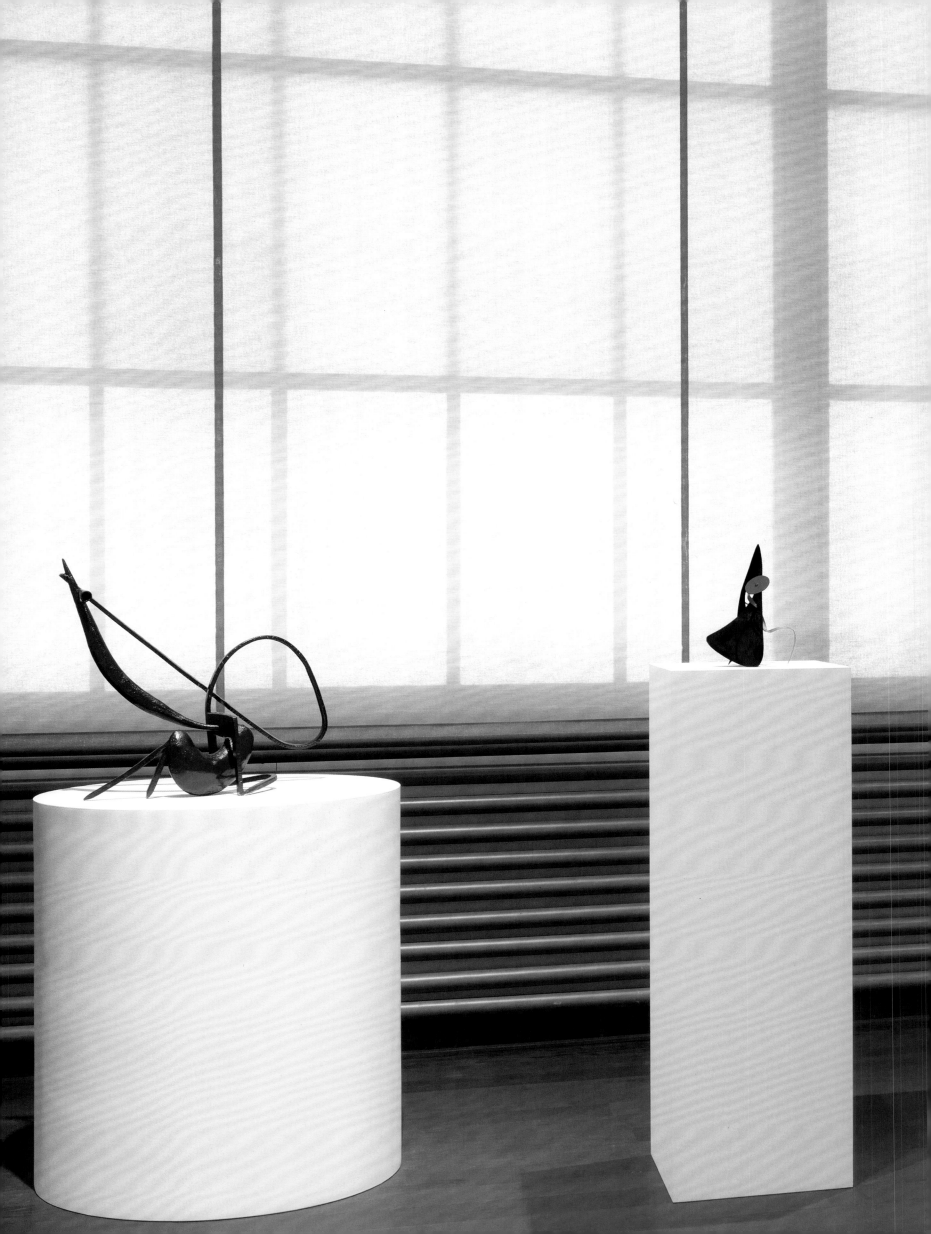

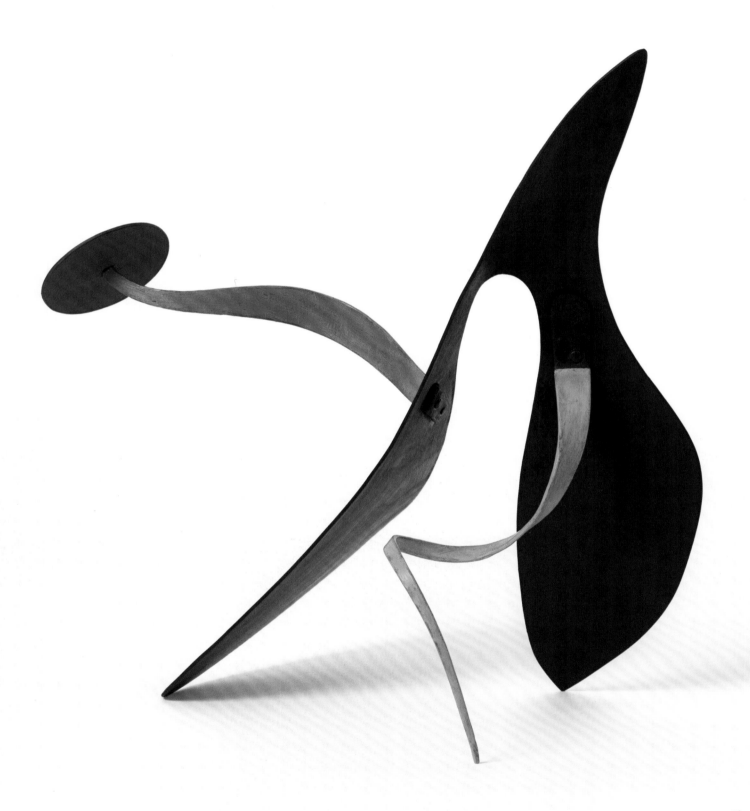

Alexander Calder
Untitled
1936

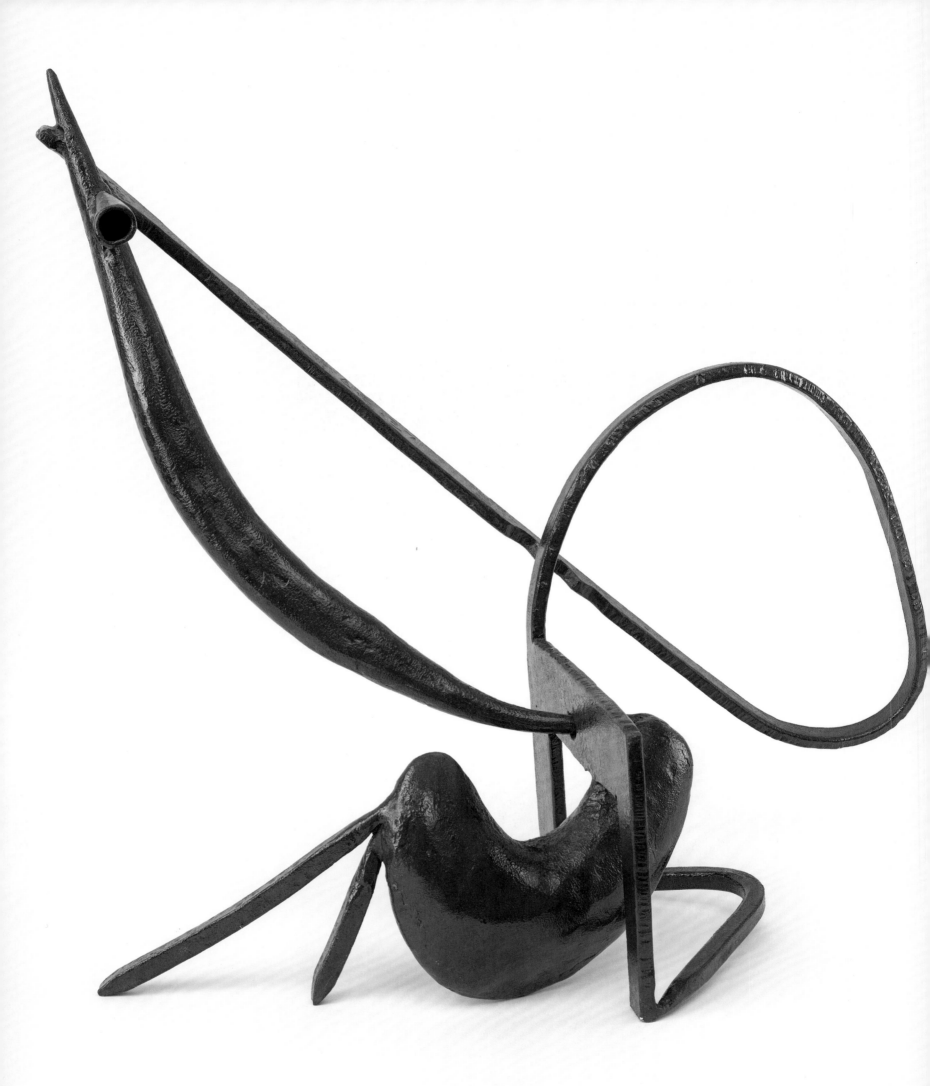

David Smith
Swung Forms
1937

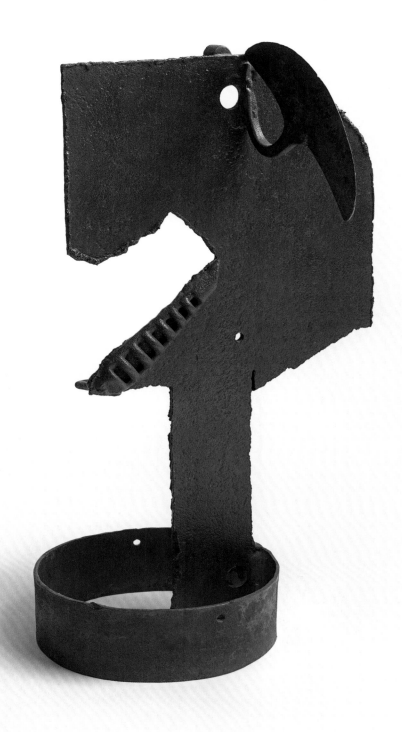

David Smith
Chain Head
1933

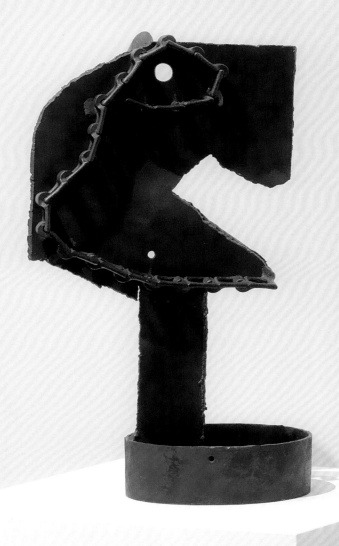

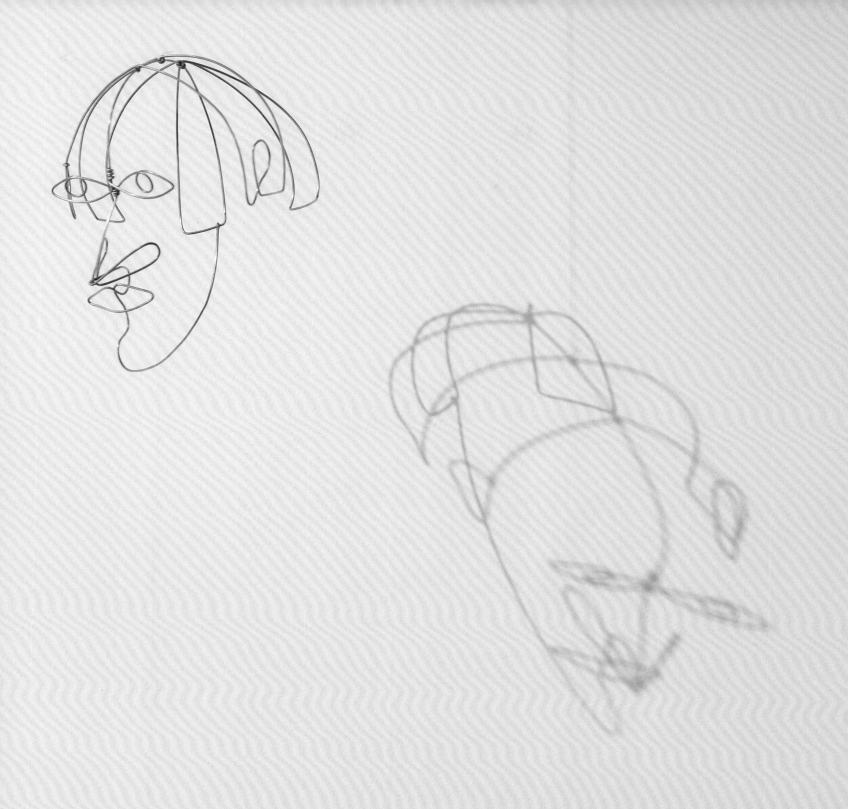

David Smith
Chain Head
1933

Alexander Calder
John Graham
ca. 1931

David Smith
Untitled
1954–57

Alexander Calder
Untitled
ca. 1946

Alexander Calder
Blue Panel
1936

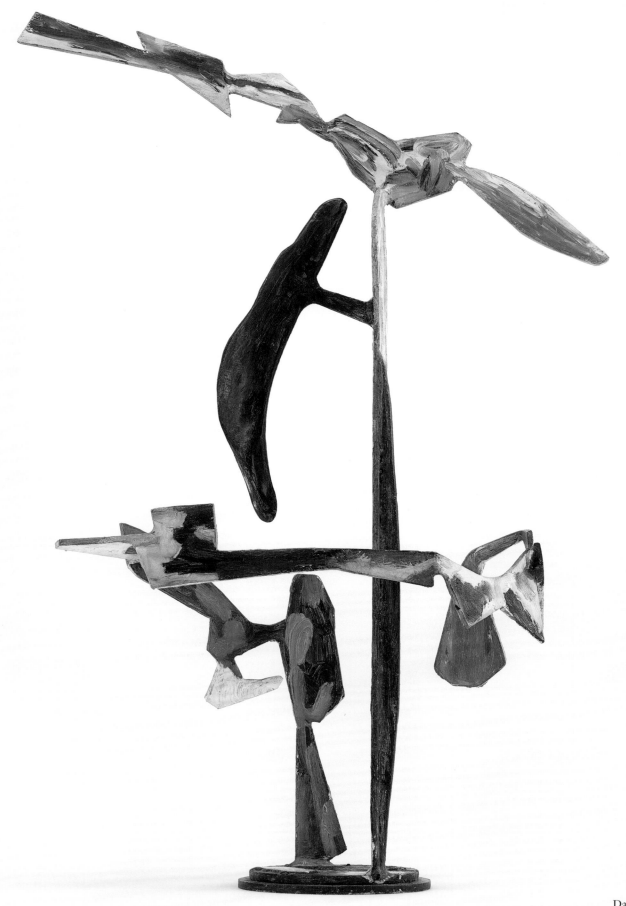

David Smith
Untitled
1954–57

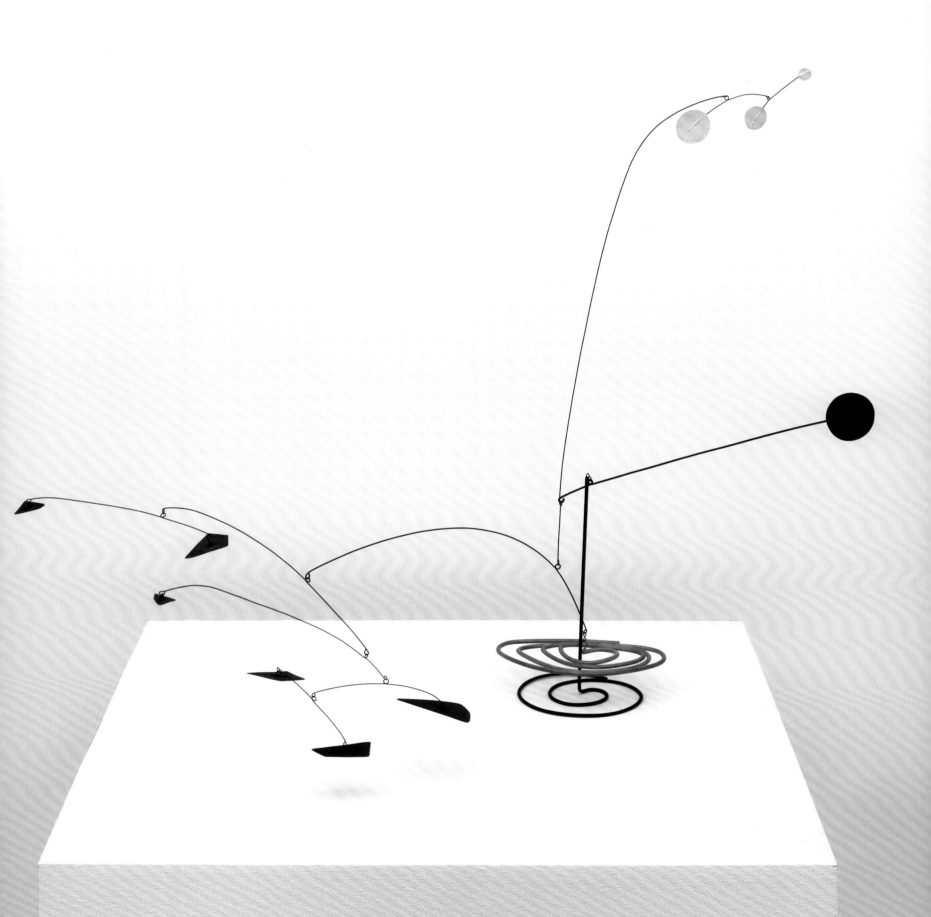

Alexander Calder
Untitled
ca. 1946

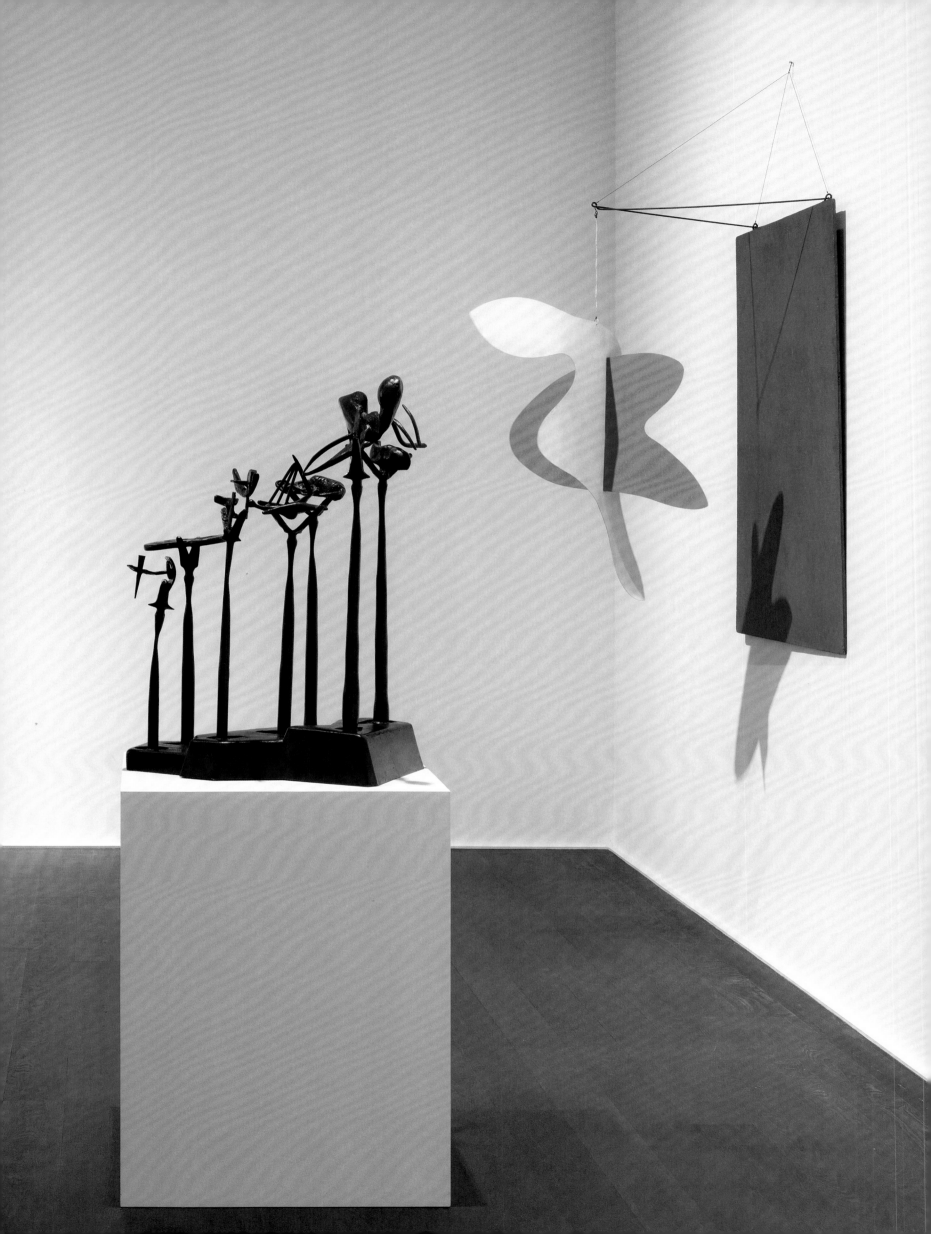

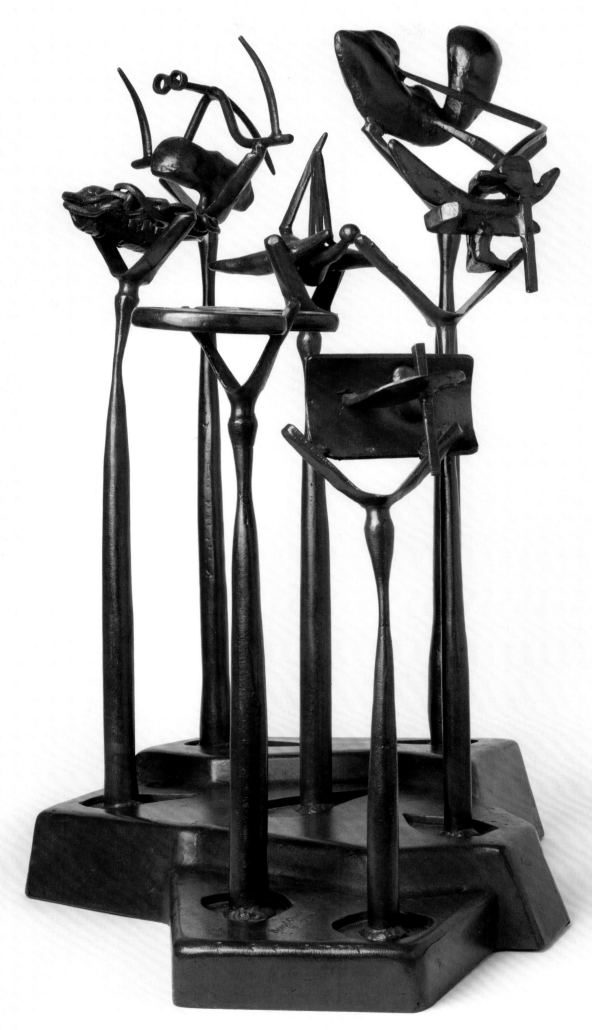

David Smith
Sacrifice
1950

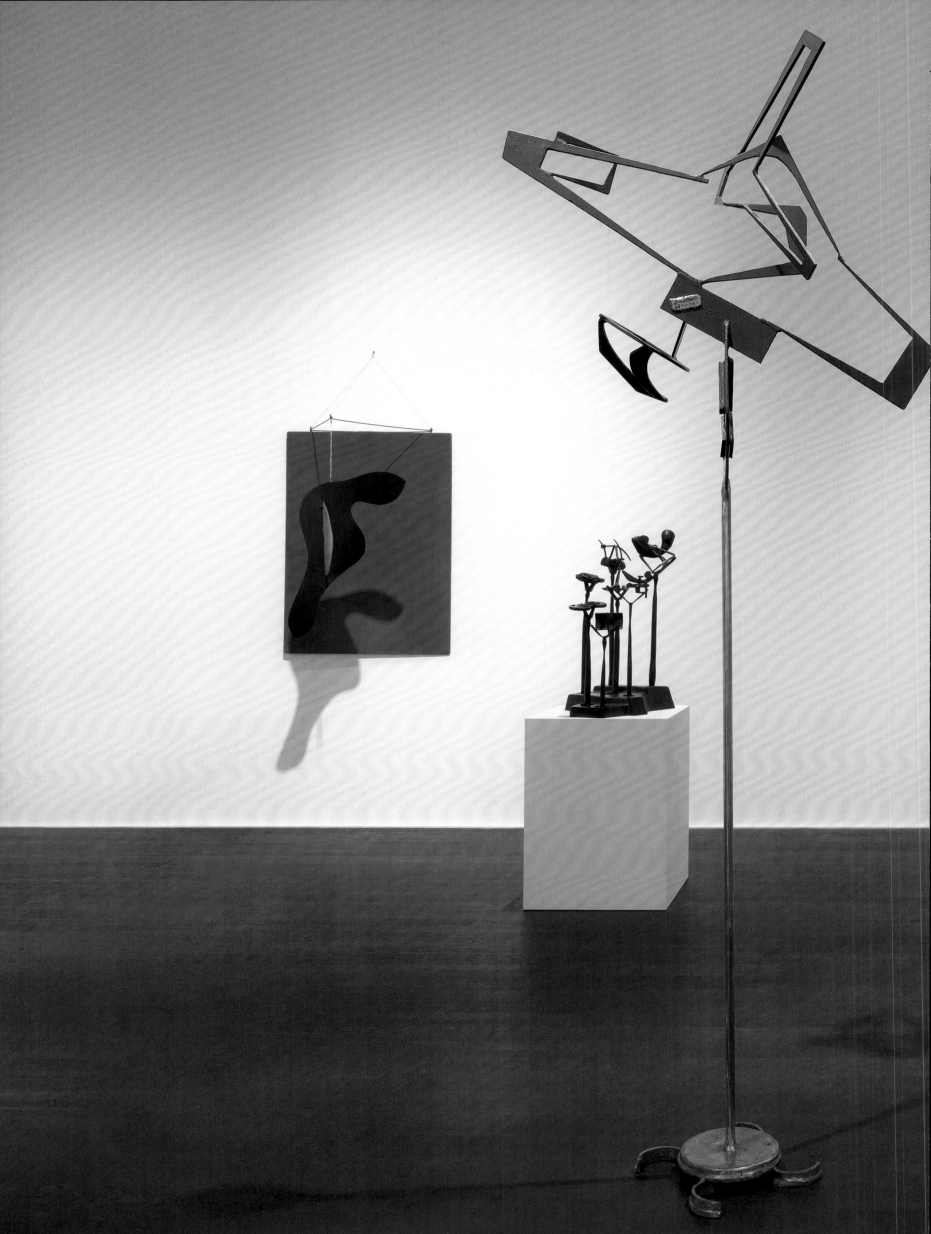

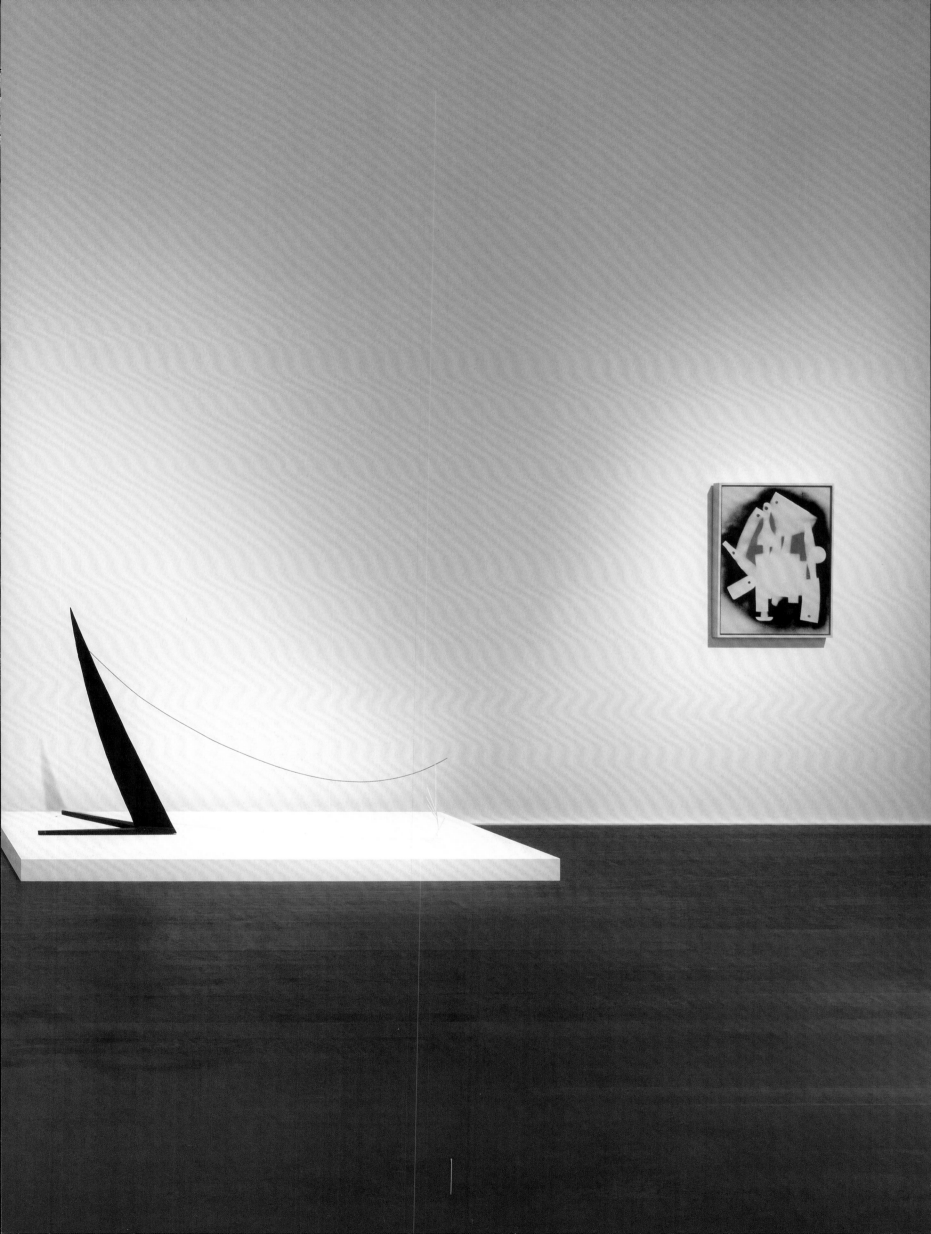

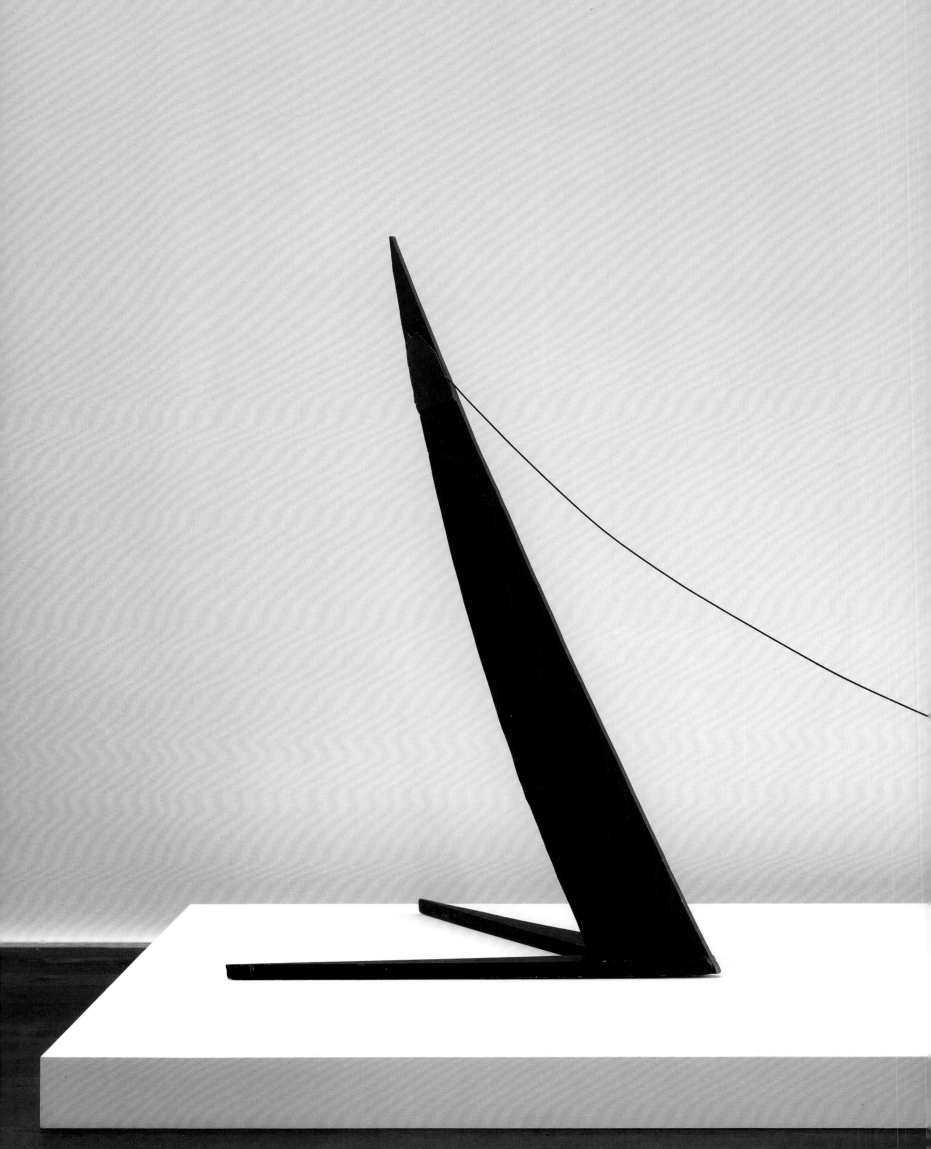

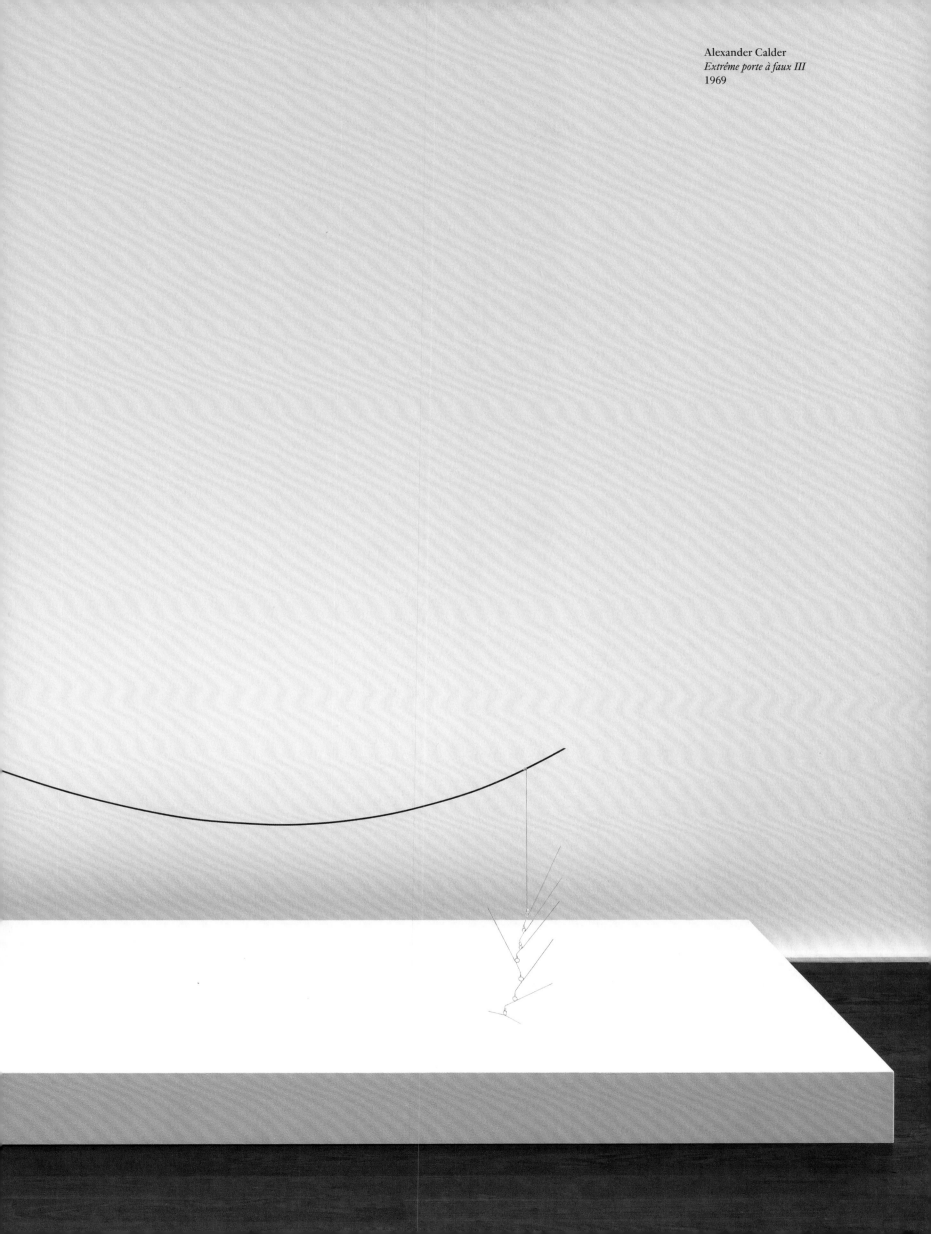

Alexander Calder
Extrême porte à faux III
1969

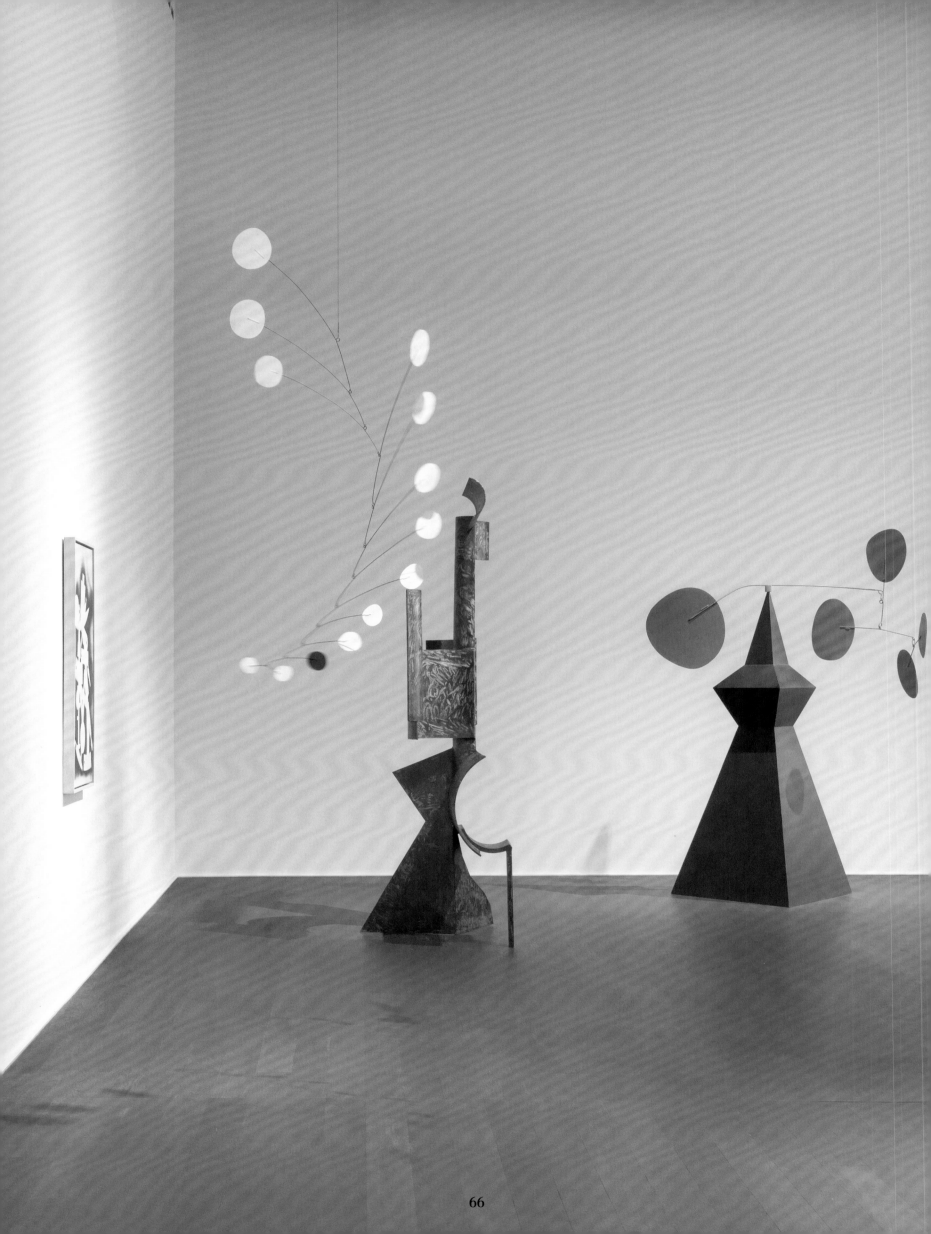

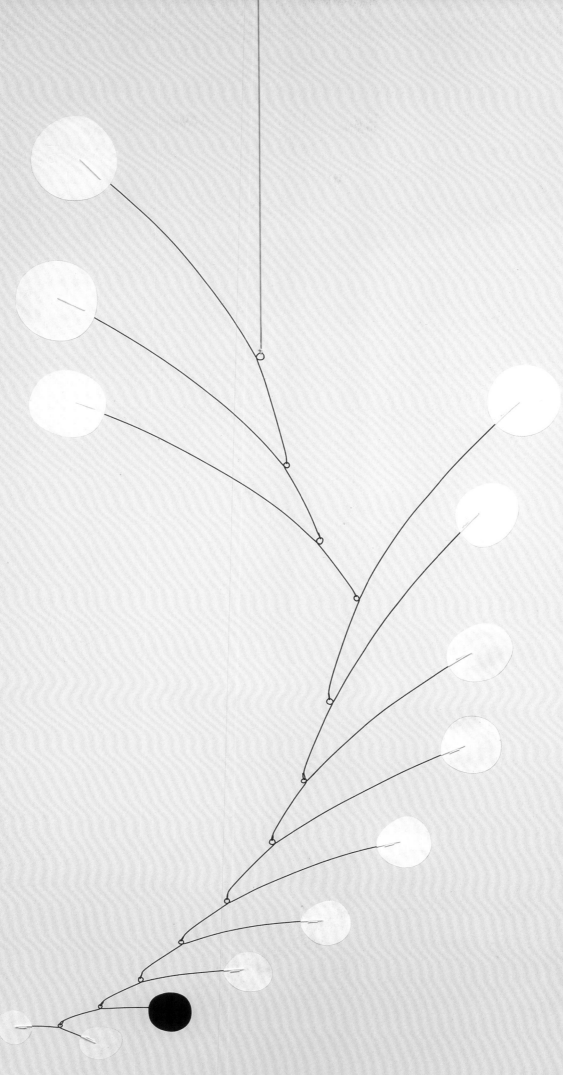

Alexander Calder
White Ordinary
1976

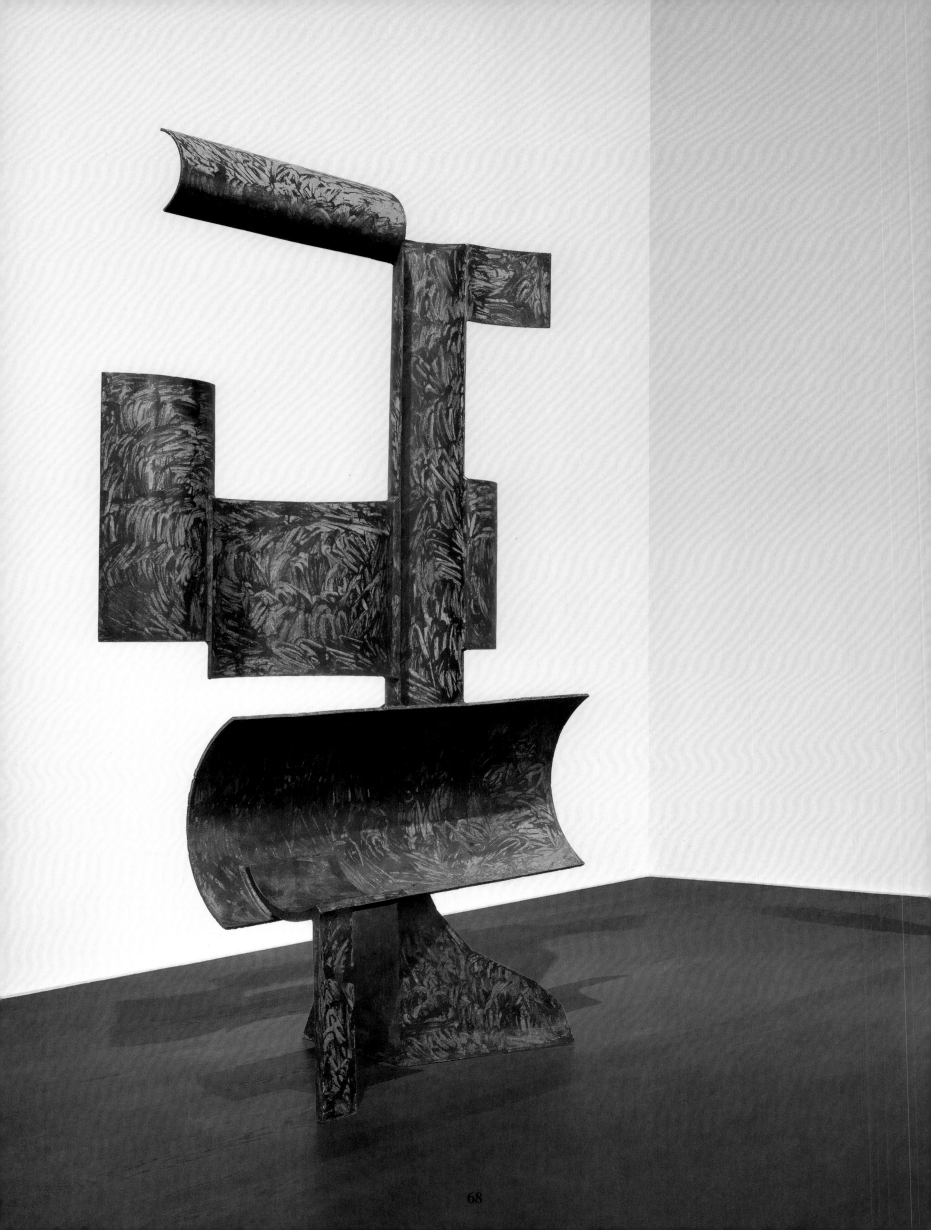

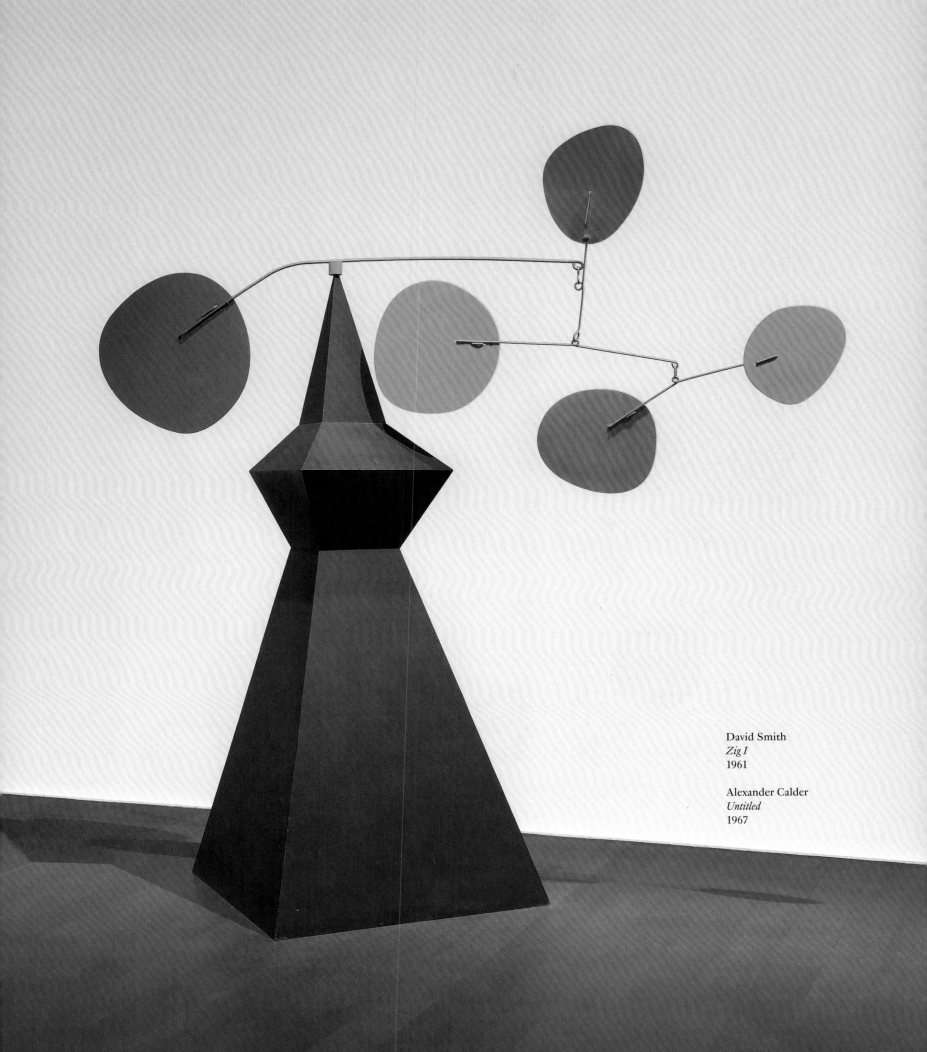

David Smith
Zig I
1961

Alexander Calder
Untitled
1967

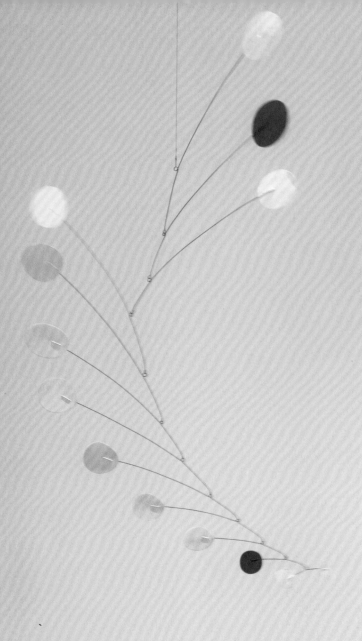

Alexander Calder
White Ordinary
1976

David Smith
Untitled
1963

David Smith
Zig I
1961

70

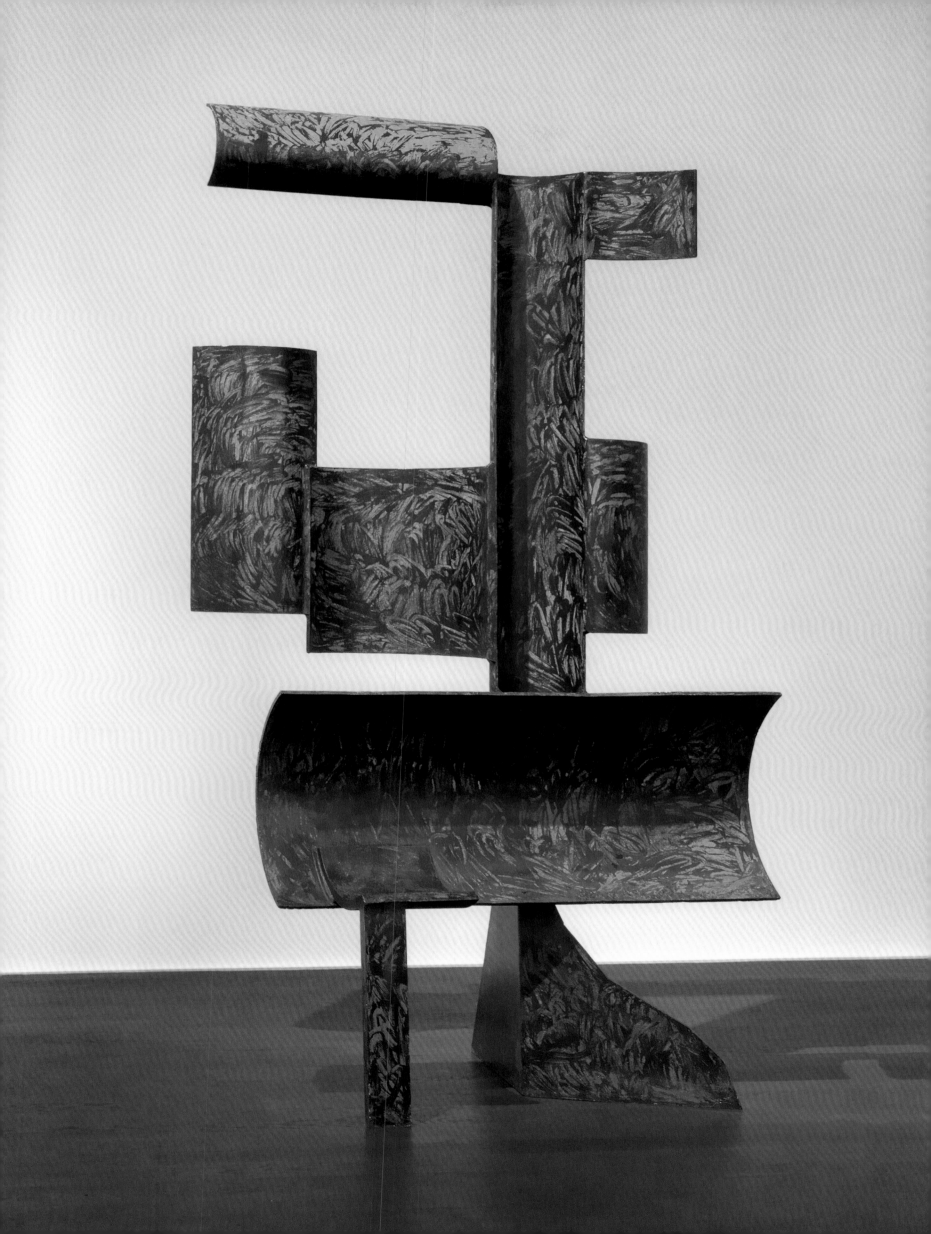

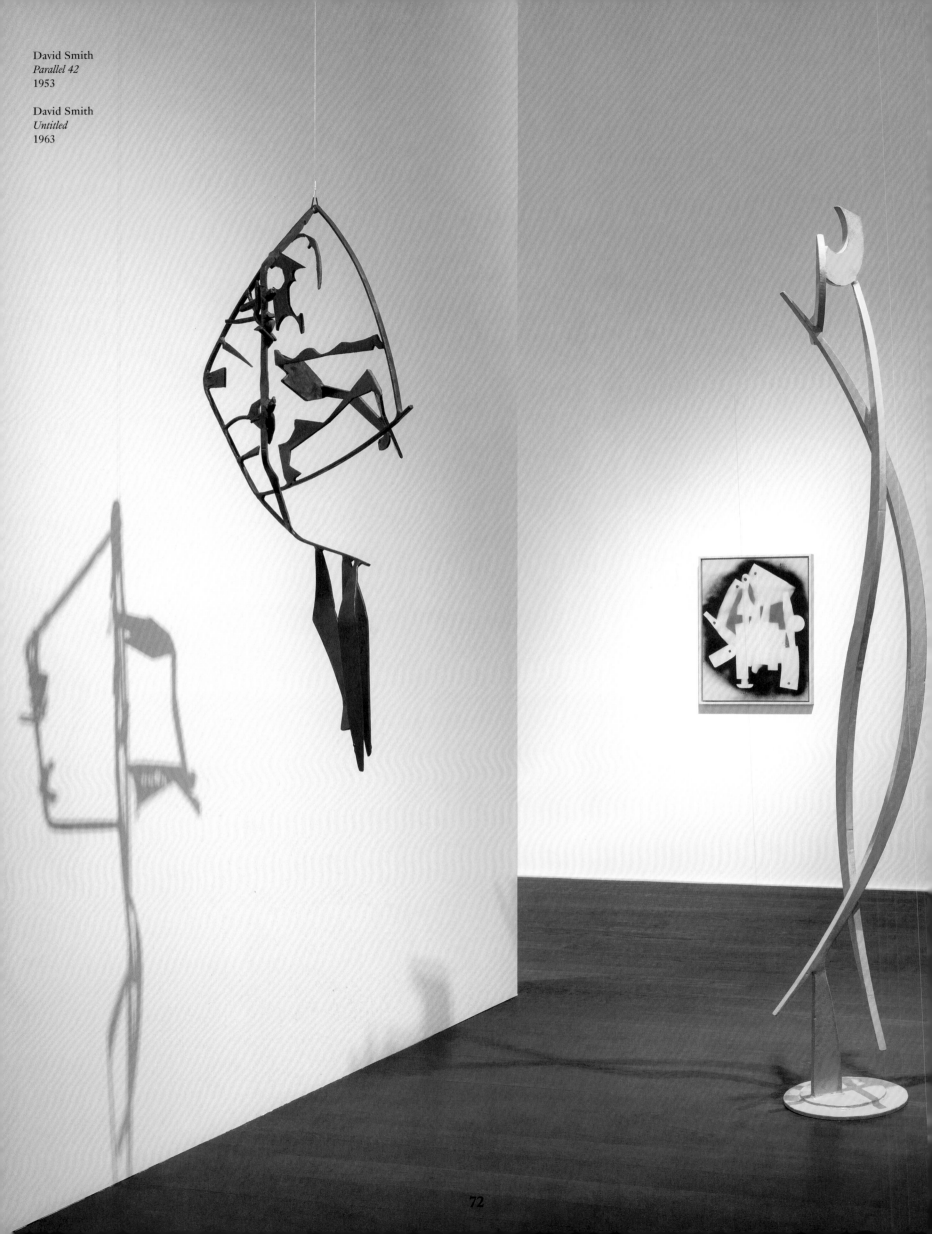

David Smith
Parallel 42
1953

David Smith
Untitled
1963

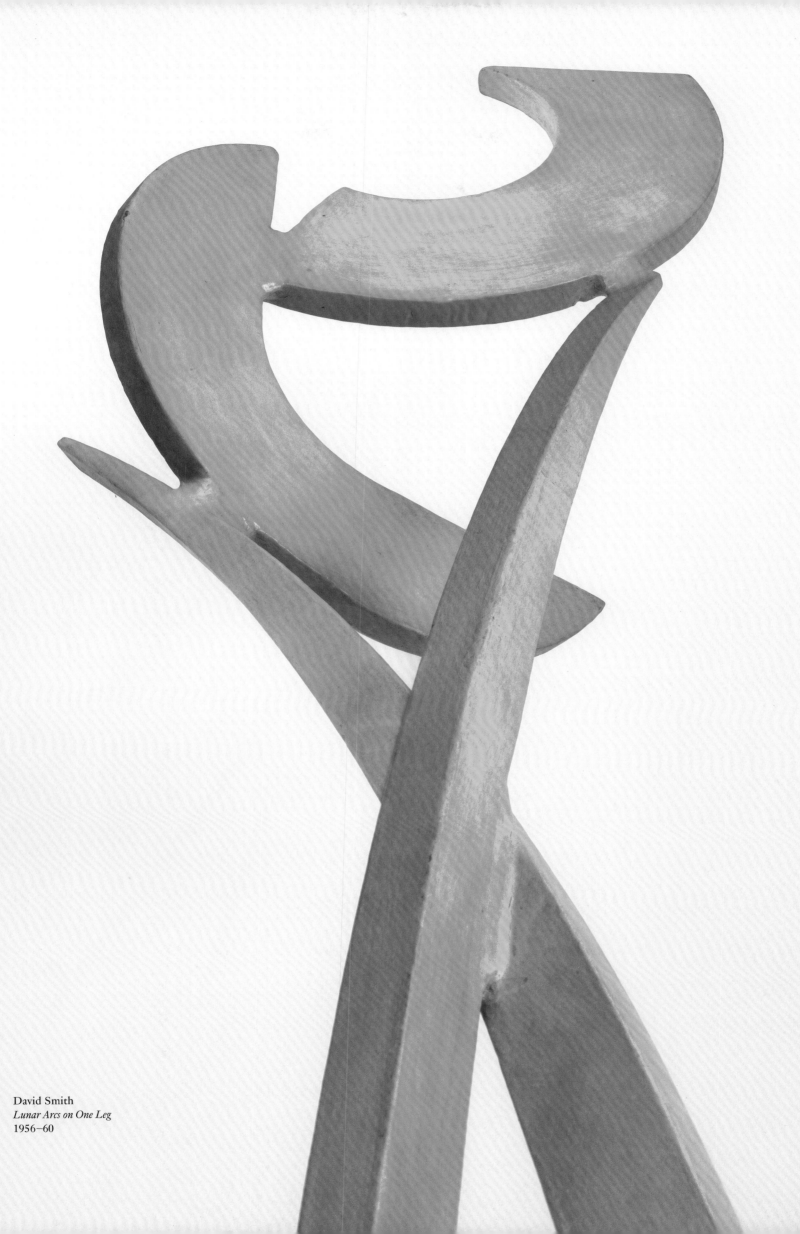

David Smith
Lunar Arcs on One Leg
1956–60

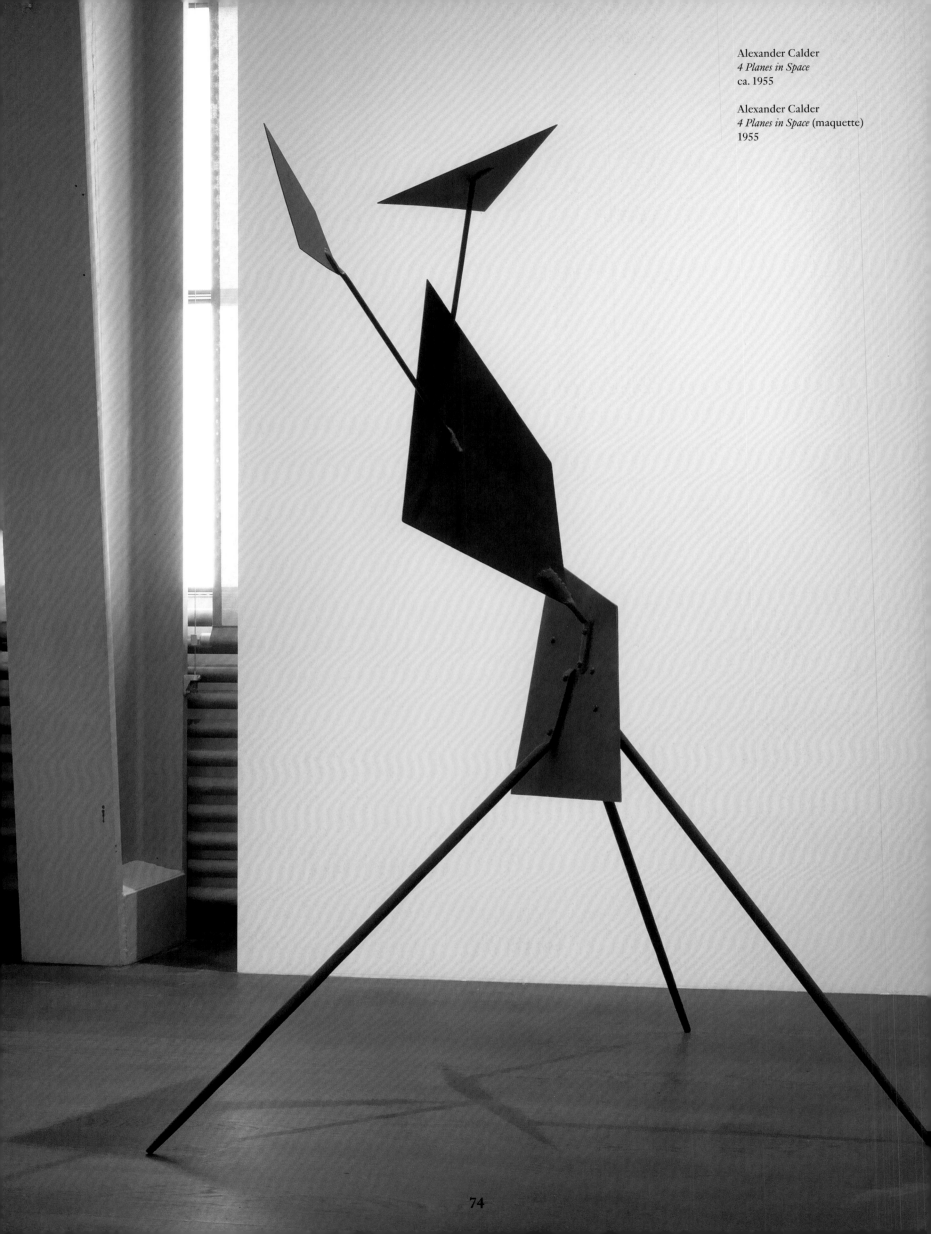

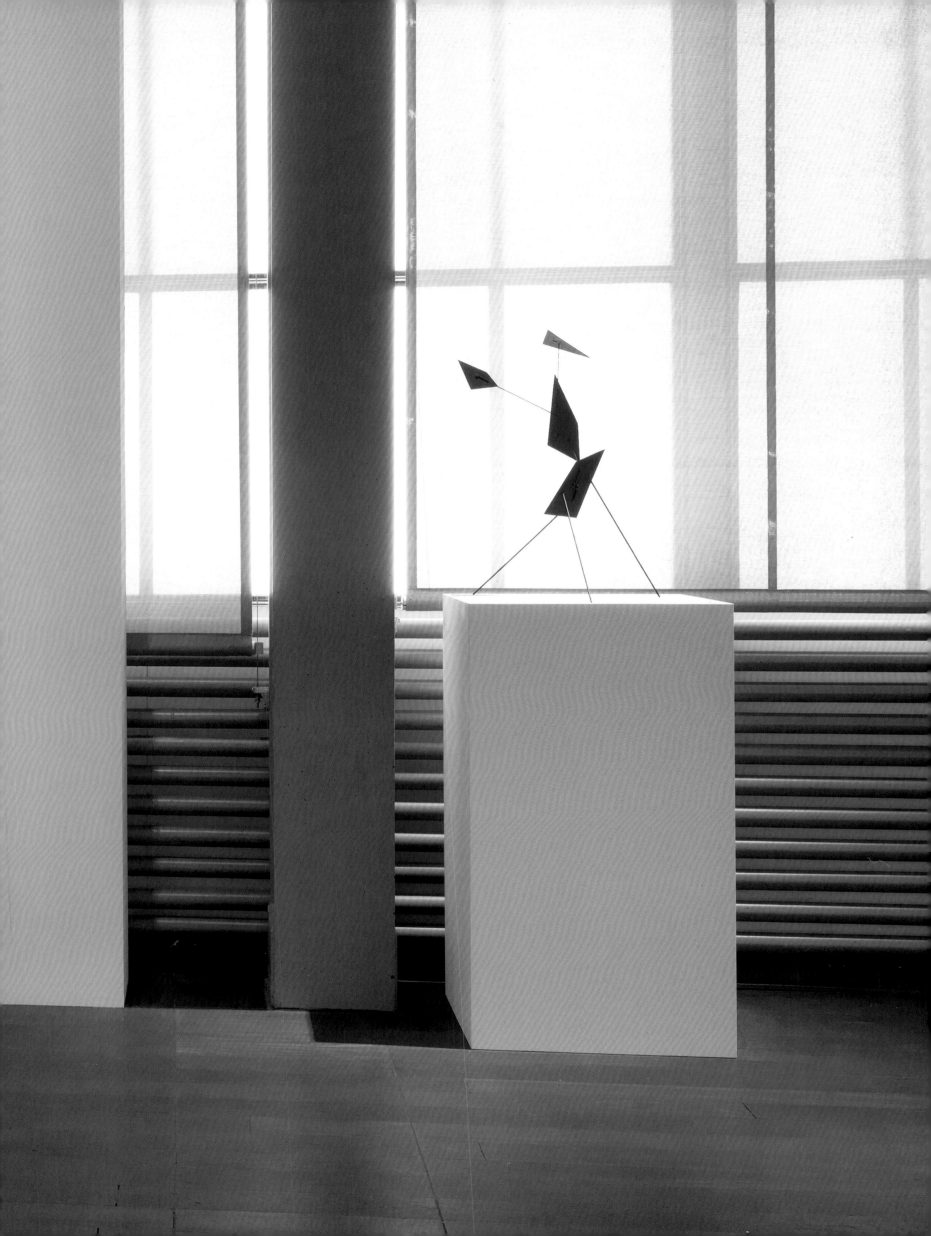

LIST OF WORKS
ALEXANDER CALDER

Pages 13, 55
John Graham
ca. 1931
Wire
26.7 × 21.6 × 26.7 cm / 10 1/2 × 8 1/2 × 10 1/2 in
Private Collection, New York

Pages 57, 60, 62
Blue Panel
1936
Plywood, sheet metal, rod, wire, string, and paint
167.3 × 92.1 × 94 cm / 65 7/8 × 36 1/4 × 37 in
Calder Foundation, New York;
Promised Gift of Alexander S. C. Rower

Pages 9, 50–51
Untitled
1936
Sheet metal and paint
28.3 × 27.9 × 22.9 cm / 11 1/8 × 11 × 9 in
Private Collection, New York

Page 48
Untitled
ca. 1942
Sheet metal, wire, and string
29.2 × 33 × 17.8 cm / 11 1/2 × 13 × 7 in
Private Collection

Pages 46–47
Untitled
1943
Sheet metal, rod, wire, and paint
83.8 × 106.7 × 71.1 cm / 33 × 42 × 28 in
Calder Foundation, New York;
Gift of Alexander S. C. Rower,
Holton Rower & The Museum of Modern Art,
New York, 2005

Pages 56, 59
Untitled
ca. 1946
Sheet metal, wire, and paint
88.9 × 109.2 × 53.3 cm / 35 × 43 × 21 in
Calder Foundation, New York

Pages 8–9, 42, 45
Red Flowers
1954
Sheet metal, wire, and paint
130.8 × 109.2 cm / 51 1/2 × 43 in
Private Collection, New York

Page 9, 43, 74
4 Planes in Space
ca. 1955
Sheet metal, rod, bolts, and paint
218.4 × 147.3 × 124.5 cm / 86 × 58 × 49 in
Calder Foundation, New York;
Gift of Anna Maria Segretario, 2008

Pages 9, 43, 75
4 Planes in Space (maquette)
1955
Sheet metal, wire, and paint
69.5 × 53.3 × 47 cm / 27 3/8 × 21 × 18 1/2 in
Calder Foundation, New York

Pages 9, 43, 66, 69
Untitled
1967
Sheet metal, rod, wire, and paint
235.6 × 216.5 × 83.8 cm / 92 3/4 × 85 1/4 × 33 in
Calder Foundation, New York

Pages 8, 63–65
Extrême porte à faux III
1969
Sheet metal, wire, and paint
112.7 × 192.4 × 60.6 cm / 44 3/8 × 75 3/4 × 23 7/8 in
Private Collection, New York

Pages 8, 66, 67, 70
White Ordinary
1976
Sheet metal, wire, and paint
161.3 × 99.1 cm / 63 1/2 × 39 in
Private Collection, New York

Pages 9, 53, 54
Chain Head
1933
Steel, painted
48.3 × 25.4 × 17.8 cm / 19 × 10 × 7 in
The Estate of David Smith

Pages 9, 50, 52
Swung Forms
1937
Steel
58.4 × 27.9 × 58.4 cm / 23 × 11 × 23 in
The Estate of David Smith

Page 49
Objects Left at the Iron Works in Brooklyn
1942
Bronze
22.9 × 35.6 × 14 cm / 9 × 14 × 5 1/2 in
The Estate of David Smith

Pages 8, 42, 44
Steel Drawing II
1945
Steel, painted
62.2 × 63.8 × 21.7 cm / 24 1/2 × 25 1/8 × 8 9/16 in
The Estate of David Smith

Pages 8, 60–62
Sacrifice
1950
Steel, painted
80.3 × 49.8 × 53 cm / 31 5/8 × 19 5/8 × 20 7/8 in
Mr. and Mrs. David Mirvish, Toronto

Page 72
Parallel 42
1953
Steel
135.9 × 66 × 48.3 cm / 53 1/2 × 26 × 19 in
The Estate of David Smith

Pages 8, 62
Construction on Star Points
1954–56
Stainless steel and steel, painted
259.1 × 101.6 × 61.6 cm / 102 × 40 × 24 1/4 in
The Estate of David Smith

Pages 8, 56, 58
Untitled
1954–57
Steel, painted
96.2 × 61.6 × 37.5 cm / 37 7/8 × 24 1/4 × 14 3/4 in
The Estate of David Smith

Pages 72, 73
Lunar Arcs on One Leg
1956–60
Steel, painted
269.6 × 48.3 × 36.5 cm / 106 1/8 × 19 × 14 3/8 in
The Estate of David Smith

Pages 66, 68, 71
Zig I
1961
Steel, painted
245.1 × 144.8 × 81.9 cm / 96 1/2 × 57 × 32 1/4 in
Private Collection

Pages 8, 42, 63, 72
Untitled
1963
Spray enamel on canvas
82.6 × 62.2 cm / 32 1/2 × 24 1/2 in
The Estate of David Smith

Pages 8, 66, 70
Untitled
1963
Spray enamel on canvas
111.8 × 61.6 cm / 44 × 24 1/4 in
The Estate of David Smith

Elizabeth Hutton Turner

Elizabeth Hutton Turner has been University Professor in the Department of Art at the University of Virginia since 2007. She has also served as the school's Vice Provost for the Arts. Before moving to UVA, Turner was a senior curator at the Phillips Collection in Washington, D.C. She is a specialist in European and American modernist art, organizing for the Phillips exhibitions on, among others, Arthur Dove, Georgia O'Keeffe, Jacob Lawrence, Pierre Bonnard, Paul Klee, and Alexander Calder. Turner has served as a consultant and board member for numerous arts and educational organizations, and now teaches full time at UVA.

Sarah Hamill

Sarah Hamill is Assistant Professor of Modern and Contemporary Art at Sarah Lawrence College. She is the author of *David Smith in Two Dimensions: Photography and the Matter of Sculpture* (Oakland: University of California Press, 2015) and, with Megan R. Luke, coeditor of *Photography and Sculpture: The Art Object in Reproduction* (Los Angeles: Getty Publications, 2017). Her current writing projects include essays on Erin Shirreff's videos, the 1970s sculptures and films of Mary Miss, and the role of the photographic detail in the historiography of sculpture.

Alexander Calder
Alexander Calder (b. 1898, Lawnton, Pennsylvania; d. 1976, New York), whose illustrious career spanned much of the twentieth century, is among the most acclaimed and influential sculptors of our time. Born into a family of celebrated though more classically trained artists, Calder utilized his innovative genius to profoundly change the course of modern art. He began in the 1920s by developing a new method of sculpting: by bending and twisting wire, he essentially "drew" three-dimensional figures in space. He is renowned for the invention of the mobile, whose suspended, abstract elements move and balance in changing harmony. From the 1950s onward, Calder increasingly devoted himself to making outdoor sculpture on a grand scale from bolted steel plate. Today, these stately titans grace public plazas in cities throughout the world.

Calder Foundation, New York
The Calder Foundation, a nonprofit organization founded in 1987 by Alexander S. C. Rower and the Calder family, is dedicated to collecting, exhibiting, preserving, and interpreting the art and archives of Alexander Calder. Charged with an unmatched collection of Calder's works, the Foundation collaborates on exhibitions and publications, organizes and maintains the Calder archives, examines works attributed to Calder, and catalogues the artist's oeuvre. The Foundation's programming also includes its own exhibitions, lectures, performances, and events on Calder as well as contemporary artists who are supported through the biannual Calder Prize and the Atelier Calder residency program in Saché, France.

David Smith
David Smith (b. 1906, Decatur, Indiana; d. 1965, Bennington, Vermont) was one of the twentieth century's preeminent sculptors and the first American artist to work directly in welded steel. After arriving in New York in 1926, he studied painting at the Art Students League before making his first sculptures in 1932. In 1940 he moved to Bolton Landing, in upstate New York. There he established his home and his workshop, Terminal Iron Works, where he constructed increasingly large and stylistically diverse sculptures in steel, bronze, painted steel, and polished stainless steel, installing many of them outdoors on his property. Rejecting arbitrary distinctions between two- and three-dimensional media, Smith explored the visual nature of sculpture and, over the course of his career, created extensive and innovative bodies of work as a painter, draftsman, and photographer.

The Estate of David Smith
The Collections of the Estate of David Smith include sculptures, paintings, drawings, and photographs by the artist, as well as an extensive archive of materials related to his life and work. Under the stewardship of his daughters, Candida and Rebecca Smith, and Executive Director Peter Stevens, the Estate encourages and supports the continued study, interpretation, and appreciation of David Smith's profound contributions to the development of twentieth-century art, and the continuing influence of his aesthetic vision on contemporary artists and a broader international audience.

Alexander Calder / David Smith
is published on the occasion of the exhibition:

Alexander Calder / David Smith
Hauser & Wirth Zürich
12 June–16 September 2017

Editor
Michaela Unterdörfer

Managing Editor
Renata Catambas

Book design
Prill Vieceli Cremers

Typography
Genath, Theinhardt

Copy editing and proofreading
Frances Malcolm

Pre-press by
LUP AG

Printed by
druckhaus köthen GmbH & Co. KG, Köthen

Photo Credits
Pages 8–9, 42–43, 48–50, 54–57, 59, 60, 62–66, 68–72, 74, 75,
Photo: Stefan Altenburger © Stefan Altenburger; pages 13,
16, 18, 19, 20 (figs. 11, 13, 14), 21, 24, 32, 34 (figs. 6, 7), 35
(figs. 9, 10), 36, 37, 39, Photo: Ugo Mulas © Ugo Mulas Heirs.
All rights reserved. Courtesy Ugo Mulas Heirs; page 14,
Photo: Andreas Feininger © Andreas Feininger. Courtesy
The Estate of David Smith; pages 14, 35, Photo: Herbert
Matter © 2017 Calder Foundation, New York. Courtesy
Calder Foundation, New York / Art Resource, New York;
page 15 (fig. 4), Photo: David Heald © David Heald. Courtesy
The Estate of David Smith; page 15 (fig. 5), Photo: David
Heald © David Heald. Courtesy Art Resource, New York,
Location: The Solomon R. Guggenheim Museum, New York;
page 16, Photo: Alberto Zanmatti © Alberto Zanmatti.
Courtesy Calder Foundation, New York / Art Resource, New
York; pages 17, 20 (fig. 12), 33, Photo: Ugo Mulas © Ugo Mulas
Heirs. All rights reserved. Courtesy The Estate of David
Smith; page 23 (fig. 19), Photo: Unknown. Courtesy Visual
Resources Collection, McIntire Department of Art and
Architectural History, University of Virginia; pages 26, 31, 34
(fig. 5), 38, Photo: Ugo Mulas © Ugo Mulas Heirs. All rights
reserved. Courtesy Calder Foundation, New York / Art
Resource, New York; pages 44, 52, 53, 58, 61, 73 © The Estate
of David Smith. Courtesy The Estate of David Smith; pages
45–47, 51, 67 © 2017 Calder Foundation, New York. Courtesy
Calder Foundation, New York / Art Resource, New York.

Credits
Pages 21 (fig. 16), 23 (figs. 17, 18, 20), 24 (fig. 22) Courtesy Visual
Resources Collection, McIntire Department of Art and
Architectural History, University of Virginia; page 24 (fig. 21)
Courtesy Calder Foundation, New York / Art Resource,
New York.

Cataloguing-in-Publication Data is available
from the Library of Congress.

Available in North America through
ARTBOOK | D.A.P.
75 Broad Street, Suite 630
New York, N.Y. 10004
Tel 212 627 1999 | Fax 212 627 9484

ISBN 978-3-906915-03-6